One Island Many Faiths

RACHEL MORTON

One Island Many Faiths

The experience of religion in Britain

Commentary by Alison Seaman and Alan S. Brown

With 70 photographs in duotone

 Thames & Hudson

For my sons, Ben, Joe and Sam

First published in the United Kingdom in 2000 by
Thames & Hudson Ltd, 181A High Holborn,
London WC1V 7QX

British Library Cataloguing-in-Publication Data
A catalogue record for this book is available from the British
Library

ISBN 0-500-01987-8

Printed and bound in Italy by Artegrafica

Contents

Introduction

Rachel Morton

Several years ago, I began photographing people of faith. I have always been drawn to individuals or communities who have a strong sense of religious identity. Perhaps it is a throwback to the days when my own family were pious and observant Jews in eastern Europe. I envy these people's sense of purpose and conviction, the fact that their lives have a clear meaning, defined in a religious or spiritual context, and that this also cements their relationships both within their family and with the wider like-minded community to which they belong.

Having a camera was my passport into those sacred moments when people encounter the divine in their lives. I was invited to weddings, funerals and initiations. Over time, I became immersed in the writings and texts of the great religions, and set about trying to portray the 'soul' of Britain as we enter a new millennium.

Working on the book was a voyage of discovery for me. I remember taking the train to the suburbs of London and being met by an extremely courteous Indian who drove me to his home; and within ten minutes we were discussing the finer points of Zoroastrian theology over a cup of tea. It was a joy, when meeting someone for the first time, to dispense with the convention of small talk and get straight to the essentials.

I have danced and clapped with ecstatic Christians at a pentecostal church in Sussex, and knelt and prayed with Muslim women in Bradford during their Eid celebrations. I have been intoxicated with incense and chanting at a Tibetan Buddhist monastery in Scotland, and I have communed with nature at a Druid Grove during the Spring Equinox. On a memorable evening, I felt united with my forebears when I celebrated Friday night among a Jewish family in north London: they spoke in Yiddish and ushered in the Sabbath as a beautiful bride, breaking bread and sharing wine in the same way that Jews have done for thousands of years.

I began my own spiritual journey several years ago, when I met an Indian Guru by the name of Guru Raj Ananda. He taught me to meditate, and his message was simple: God is here and now, there is no separation, and He does not belong to any one religion. He is within and beyond you and when you allow yourself to be truly in the moment, you will realize yourself as one with God.

He was, I believe, an enlightened man, and his teachings had a profound effect on me: they awakened me to the transcendent in life. My belief in the power of religion to give strength and joy to its adherents grew as I spent time among people of widely differing theological perspectives. From the Sikh in Southall to the Zen Buddhist in Northumberland, from the Anglican clown-priest to the Hindu convert, all the people I met, talked with and photographed had their 'version' of the truth which gave meaning to their life. Slowly I came to realize that what all these beliefs have in common is that they provide us, in the words of our contemporary philosopher and sage Joseph Campbell, with a 'myth to live our life by'.

By myth, Campbell meant the metaphysical or God-given explanation for why we are here. Carl Jung once said that, although we cannot prove the existence of God, we all have a psychic need for the numinous, and that people with spiritual faith have a greater sense of purpose in their life.

The pictures in my book show people from all walks of life, in a state of communion with the divine. A monk in prayer, or simply a woman cooking a meal for her community - their daily lives are informed by the beliefs to which they subscribe.

I decided that it was important for the people in the book to speak for themselves. There is, however, at the back, a commentary, written by Alison Seaman and Alan Brown of Shap, the Working Party on World Religion in Education, which is extremely useful for placing the subjects in their context. I asked people to write something about their personal experience of God or spirituality: how they came to have their faith in the first place, how their religion has guided them through a crisis, how their beliefs underpin their lives. I did not want definitions of religions but testimonies of spiritual experience.

I have tried to open a window into people's hearts, to take a picture of some whom one might look at with prejudice or incomprehension and show that they too, regardless of religion, race or age, have a yearning for something beyond the mundane, a need for the sacred to enrich their life.

I have included not only the six main religions - Christianity, Judaism, Islam, Hinduism, Sikhism and Buddhism (which in turn break down into many sub-groups), but also the smaller religions such as Jainism and Zoroastrianism. I have also included groups such as the indigenous pagan and 'New Age' movements, which, although not necessarily formal religions, are still expressions of spirituality in this country. There is, as well, a photograph depicting the 'non-affiliated' seeker of spirituality – many people in this country would subscribe to that description of themselves, although by the very nature of their independence, they are the hardest to measure in terms of numbers.

It must be pointed out that it is impossible to portray any one subject as the representative of his or her faith or denomination - for instance, if you put two Anglicans together they would be as likely to disagree as to agree on key issues such as the Virgin Birth or the Resurrection, and so neither could claim to be the only spokesperson. People of the same faith share many, but by no means all, of the same religious or spiritual beliefs, so in portraying different traditions, I have selected people who hold typical views within each tradition, without presenting them as exclusively definitive.

In researching the book, I sought advise from Inform, the government-backed agency set up to provide guidelines on new religious movements. I made a decision early on not to include any controversial movements, which provide a physical or psychological threat to the individual involved or society at large. Those such as Wicca (modern witchcraft) or Transcendental Meditation, although not necessarily approved of by some of the established religions, are included.

The subjects of this book, all regular members of the British public, are united in the fact that their faith enables them to live in a state of encounter with the 'beyond', to escape from the linear world into the ever-present. I hope one day we will realize that that which unites us is bigger than that which drives us apart.

Tina Durojaiya,

The Aladura International Church
(African Spiritual Church),
at Sunday worship,
London.

It is very difficult to explain my relationship with God; to me God is all in all, he is my father, mother, brother, sister and friend. Whenever I am down, I turn to him in prayer for comfort, strength and relief. He is always there for me.

When I was 18 years old, I had a heart operation. Both my parents were away in Nigeria. Before going to the hospital I felt alone and frightened. I kneeled and prayed. I committed the operation into God's hands and I asked him to take total control, which he did. After the operation, in the intensive care unit, I looked around me and saw tubes all around. Twelve hours later, the doctor came to remove the tubes that were attached to me and found that one of the tubes was stuck inside me. I started to pray again and it took three doctors to pull the tube out of me. During that time, I felt God's hand on my shoulder and I knew that He was with me. I had nothing to fear.

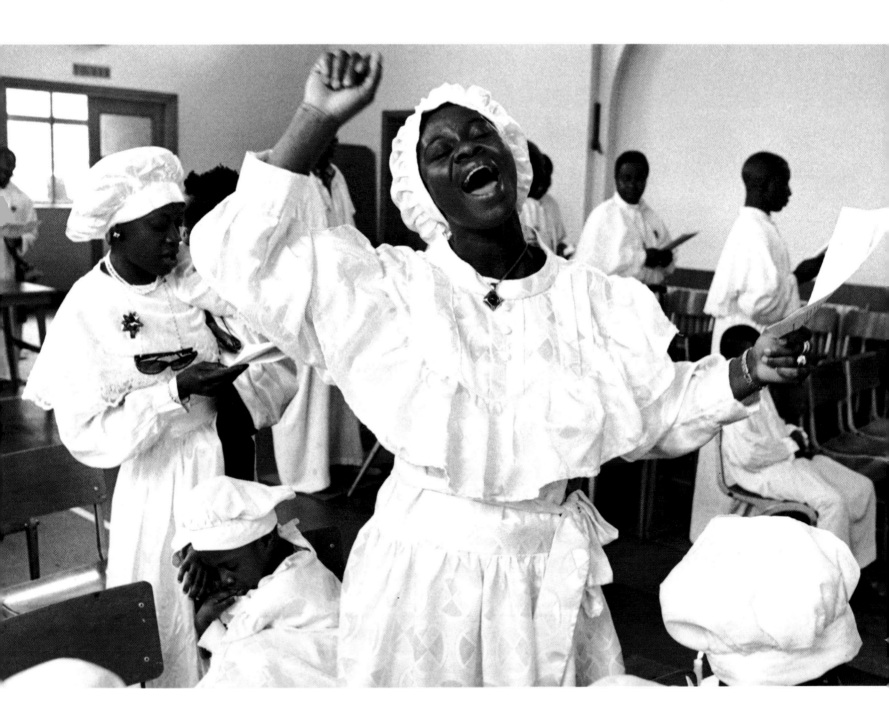

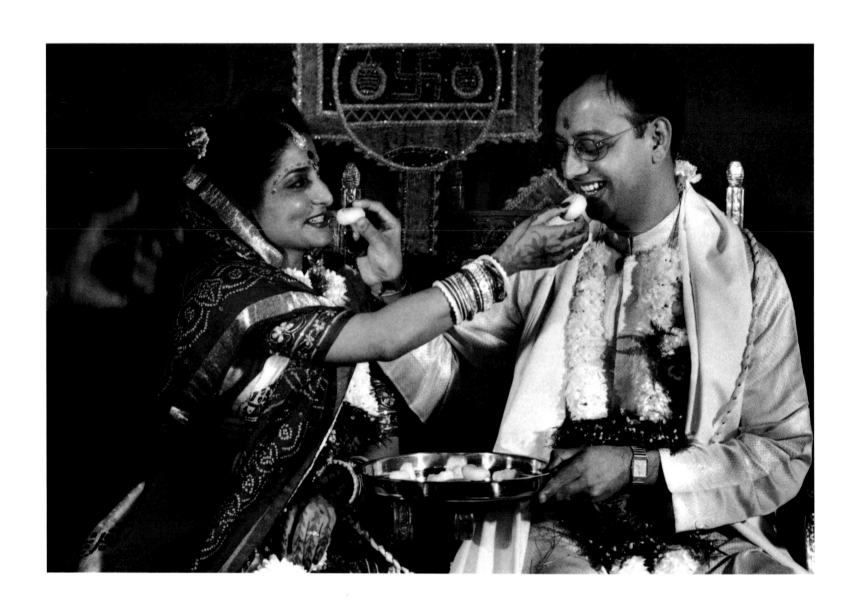

Bharat Chauhan,

Hindu (Swaminarayan),
at his wedding,
London.

As I was not going to become a sadhu (monk), it was expected by my peers that I should get married and settle down in life. For a house-holder, the Hindu religion recognizes marriage as a spiritual path and prescribes it as a way to achieve the ultimate salvation – God's palace Akshaardham. I have been lucky to have a wife who also has a strong belief in our religion.

When I migrated to the UK, I felt a great cultural shock, a feeling of alienation and of loneliness. I had no means of socializing and no affili-ations – I became aloof. When I was introduced to the Swaminarayan Temple– a Hindu sect - that was a turning point in my life. I was re-united with my spiritual aspirations that I had left behind in my motherland.

That was further intensified for me after I met the God-realized Saint, Pramukh Swami Maharaj. I developed an inner peace of mind and his guidelines gave me a motivation to dedicate myself to God.

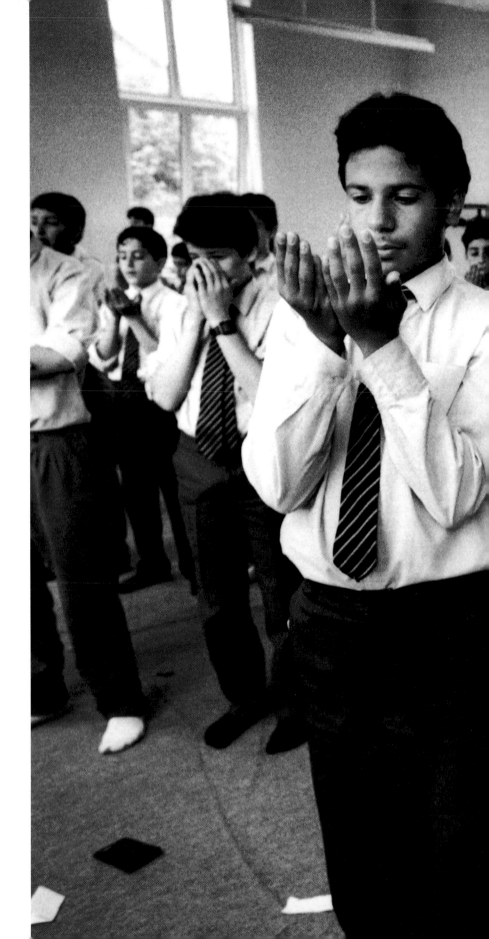

Mehdi Al–Asadi,

Muslim, praying at school,
Al Sadiq and Al Zahra Muslim School,
London.

I am a Muslim. Prayer for us is our constant loving link with the sustaining power of God. The worship and adoration we give to the supreme controller reaches its peak when we place our forehead on the floor – thereby achieving the height of our humanity in a total conscious submittance

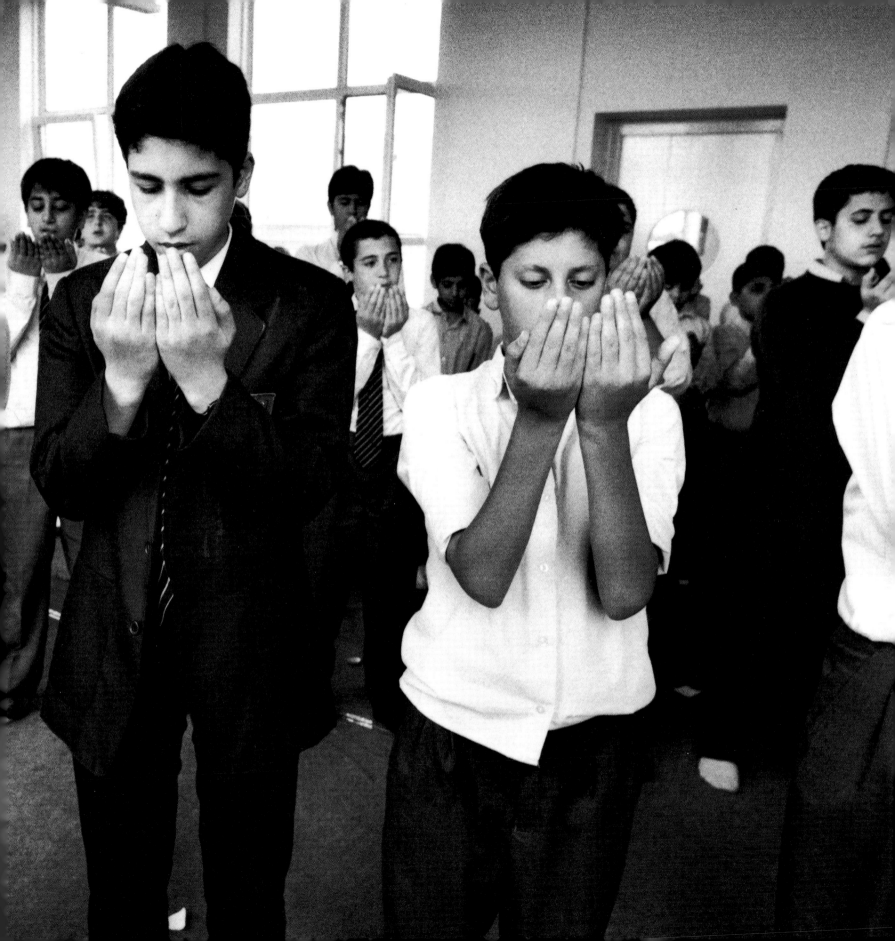

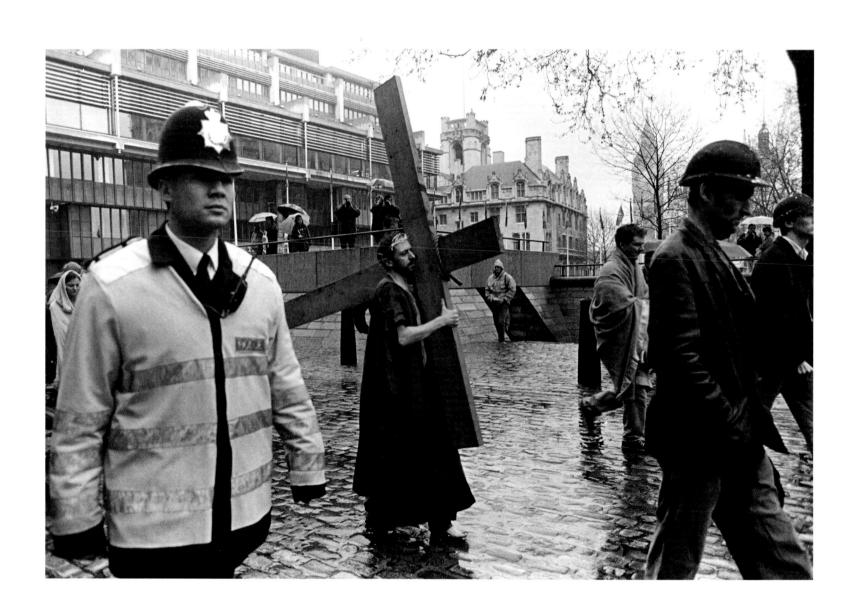

Andrew Wheaton,

Christian,
Enactment of the Crucifixion
at Westminster.

I am an actor, and I set up the 'Rites of Passage' company several years ago. Although I am a Christian, I am not a committed Christian; I believe in Him, yet my faith is somewhat wanting. But the day I dragged that cross through London will remain with me forever.

During the rehearsals leading up to the event, I approached the role as any actor might. But when it came to the day, it no longer felt like acting. I suppose that, like a priest, I became a vessel. That sounds corny, but unlike doing a West End show, there was nothing egotistical about it. I was carrying out the portrayal of an action that has been with us for 2,000 years. I was no longer important, but what I was doing was. Earlier, I had prayed that Jesus would forgive me for daring to impersonate him. As soon as we began, with thousands of people following us, I felt no such fear. What I was doing was purely for others.

As an actor, you have to empathize with the character you are playing – their ego rubs off on yours. Playing the greatest man in the world, I felt no ego whatsoever. It was, for me, a truly humbling experience.

Dechen Drolkar,

Buddhist (Tibetan),
in the Shrine Room,
Samye Ling Monastery,
Dumfriesshire,
Scotland.

In Buddhism, one takes refuge in the enlightened ones, in order to gain for oneself that same freedom of mind, and therefore be able to help all other sentient beings still suffering because they haven't yet found the unlimited potential of their mind. 'Dharma', the teaching of the Buddha, is the path one takes to do that. One who starts to practise Dharma must already have got to a stage of total disgust with suffering.

In Vajrayana Buddhism (Tibetan Buddhism), we have ritual practice, which involves body, speech and mind, all at once, and musical instruments are used. The tunes or melodies played by the different instruments once appeared in that way in the minds of enlightened masters who then made them available to be played accordingly, and so now they can inspire us by taking us somehow into that special space.

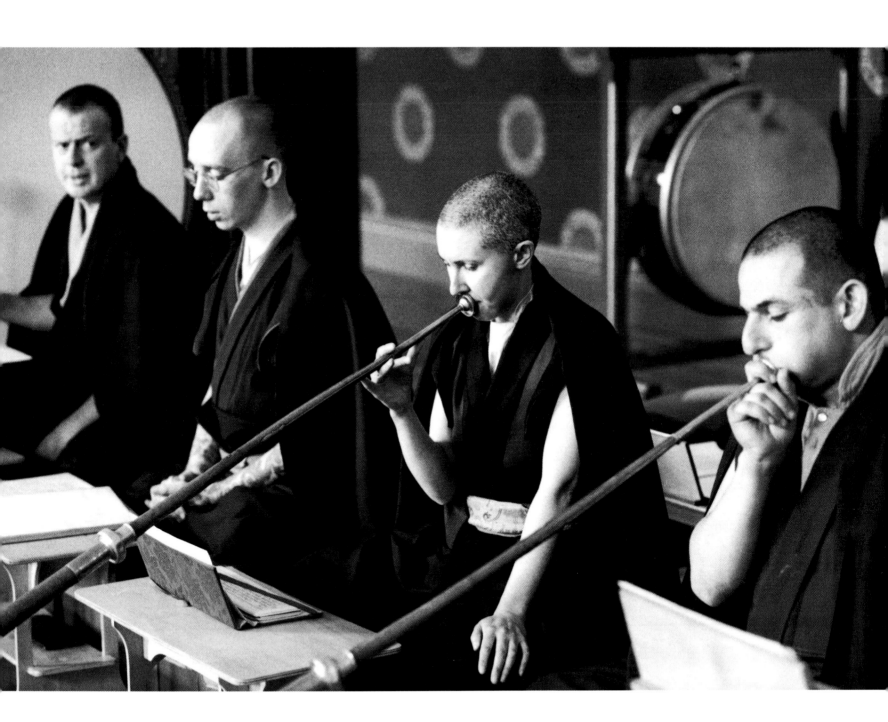

Brother Paschal,

Anglican friar,
hearing confession,
Alnmouth Friary,
Northumberland.

If only walls could talk! These walls would rejoice over the burdens laid down, the fear faced and the hope grasped. Here, in the transparent meeting of an individual with God, the Divine Comedy is effected and joy replaces sorrow, laughter follows tears, here, time after time, year after year, regularly or just once in a lifetime, Christ smiles the bruised Christian into smiling again.

As a teenager, confession was always a returning to someone, to Christ. When I failed in friendship with Him, with others or within myself, I knew that there was always a way through the consequences of my 'gone-wrongness'. I needn't be paralysed by my mistakes - what a relief to discover that I could 'begin again' and have another go...

Now, as a Franciscan priest, I assist others to discover the reconciliation that is offered by God in Christ. The aspect of penitence and reconciliation, of 'dying and rising' from self to Christ is at the heart of the Christian experience. In an undiluted way, I'm involved in the regular assurance of God's promise of new life for wounded hearts and lives. Through the door of this little room, I discover again and again that there is no escape from love.

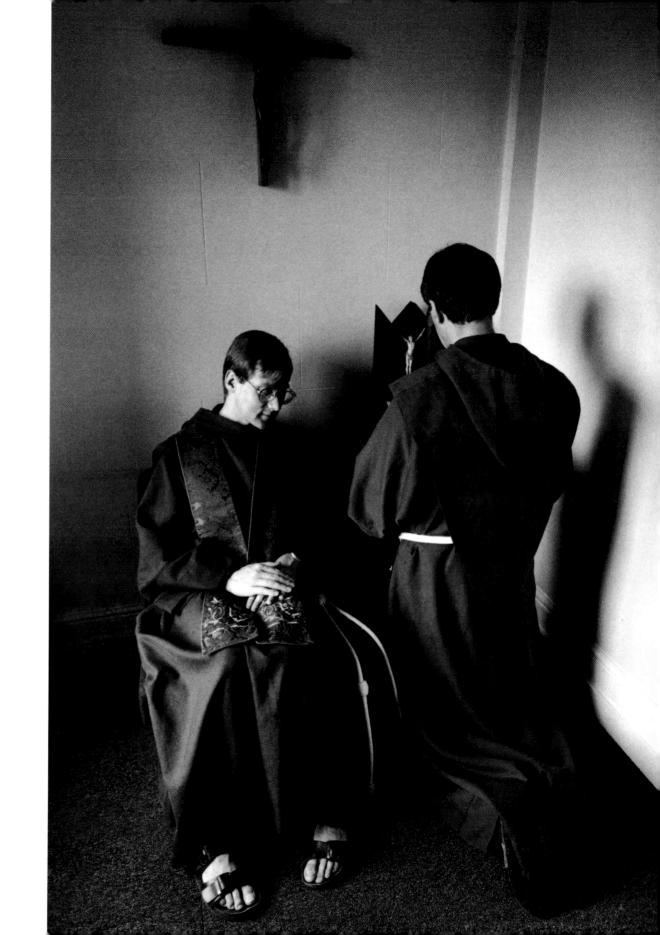

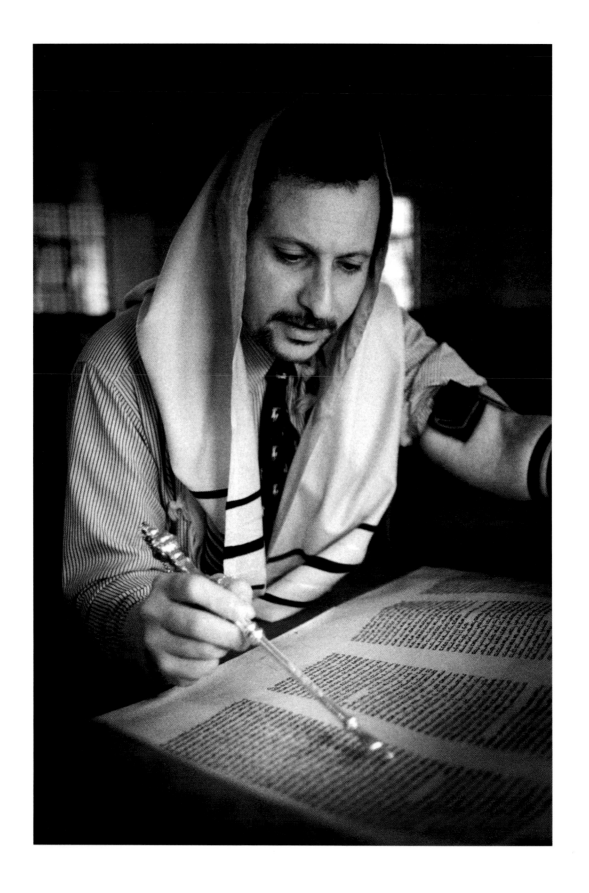

Eliyahu Khalastchy,

Jewish (Sephardic),
practising a portion of the Torah (the Law),
Bevis Marks Synagogue,
London.

The Torah is written in Hebrew, on parchment from a kosher animal, with a quill from a kosher bird, in kosher ink.

When I am praying, I put on my Tefillin (straps on my arms and my head): G-d commanded us to have a sign on our arm, close to the heart, and signs on our head, between the eyes, to show we submit ourselves to G-d's authority. And I wear a Tallith (prayer shawl), the fringes of which remind me to follow G-d's Commandments. (I write G-d without the vowel because Jews do not write out His full name as a mark of respect.)

I have always held my religion close to my heart, but I didn't practise it in my country. Before coming to Britain I lived in a war-torn country where practising my religion was frowned upon. In the war, I was working in an ambulance that was bombed. I was taken for dead and about to be buried alive when one of my fellow soldiers noticed a little movement in my toe. He begged the doctor to save me. My commander said I must have had someone watching over me in Heaven.

The word Jew comes from the Hebrew to thank G-d for his kindness. When I put on my Tallith and Tefillin I feel I am being held in the hands of G-d and I remember what He did for me and what He is still doing.

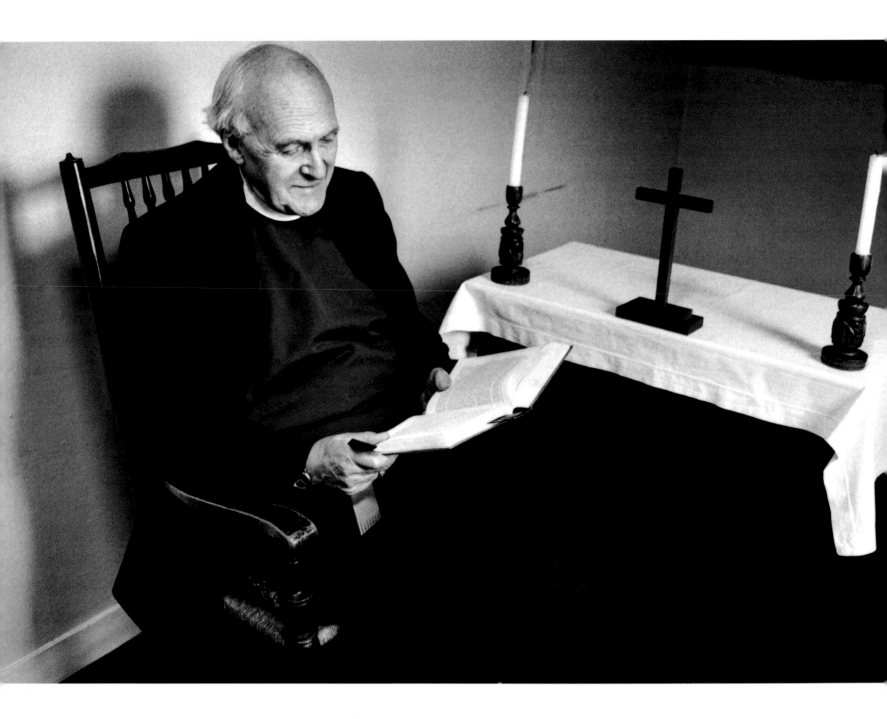

Bishop Montefiore,

Anglican,
in his attic chapel,
London.

I grew up in a Jewish household. Although my parents were not strictly observant, they were both deeply religious, and I caught my belief in God from them. Then, at the age of sixteen, I became a Christian while away at school, although I knew nothing about Christianity whatsoever. It was a bolt from the blue, the result of a vision. I was alone one afternoon in my study, and there appeared before me a figure in white. I can't think how, but immediately I knew it was Jesus, and he said 'follow me', and I have tried to do so ever since (not always very well).

The experience at the time gave me enormous joy. The memory of it is still with me. I was ordained not because I really wanted to be, but because I knew God wanted it, and I have continued to feel this kind of pressure throughout my life. I've never had another vision, and I am happy that this is so. One is enough! Out of it has come a discipleship of Christ who brings me into God's presence, and as his love beats down upon me, I know I am accepted by God even when I ought to be unacceptable.

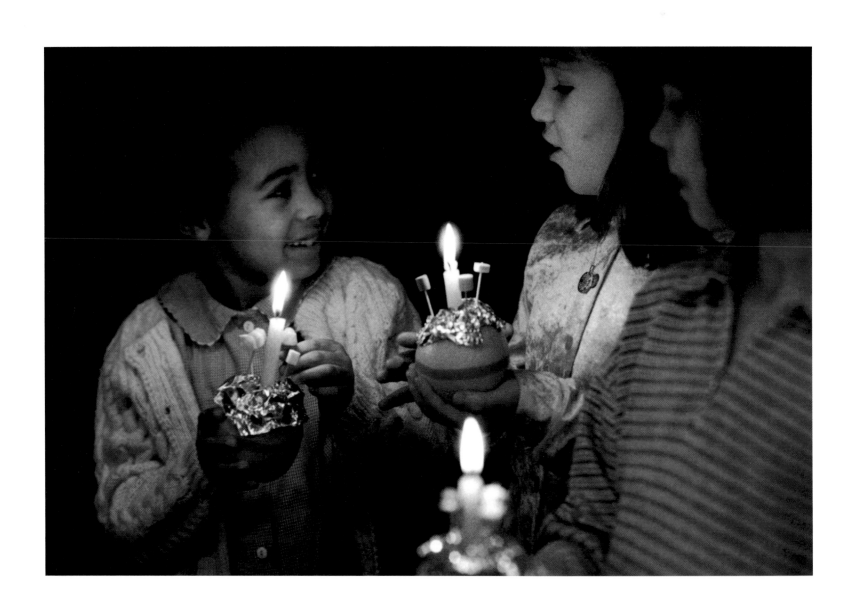

Catherine L'Estrange,

Anglican,
'Christingle' Childrens' Christmas Service,
All Saints Church,
Highams Park, Essex.

I go to All Saints Church in Highams Park. I go to Sunday school. I am going to talk about Sunday school. I like it because I play lots of games and I meet all my friends and learn lots about Jesus. I also like Communion because we all gather round and have bread, so when I am hungry it's good because I can have some bread to fill my tummy up.

I sort of believe in God because you can't see Him... but if He's not a person how could He make you when He doesn't have any hands?

Jon Randall,

Witch (Wicca),
invoking Earth Elements into the Circle,
Enfield, Middlesex.

As Wiccans or Witches, we are always aware of the natural world, and what is going on around us, as our festivals are based on the turning of the seasons. This we know as the 'Wheel of the Year'. Wicca is a nature-based religion, so we try to celebrate our rituals outside, wherever possible. Even though we live in a town, there are still some places we can use for our rituals. And when we can't celebrate outside, we bring some of the Gods' and Goddess' gifts inside for our rituals.

Wicca is very much a celebratory religion. Our festivals always include feasting, music and merriment – just like the best parties. We give thanks for a good harvest, the return of the Sun in the depth of winter, our friends and predecessors who have left this realm, and life in all its richness.

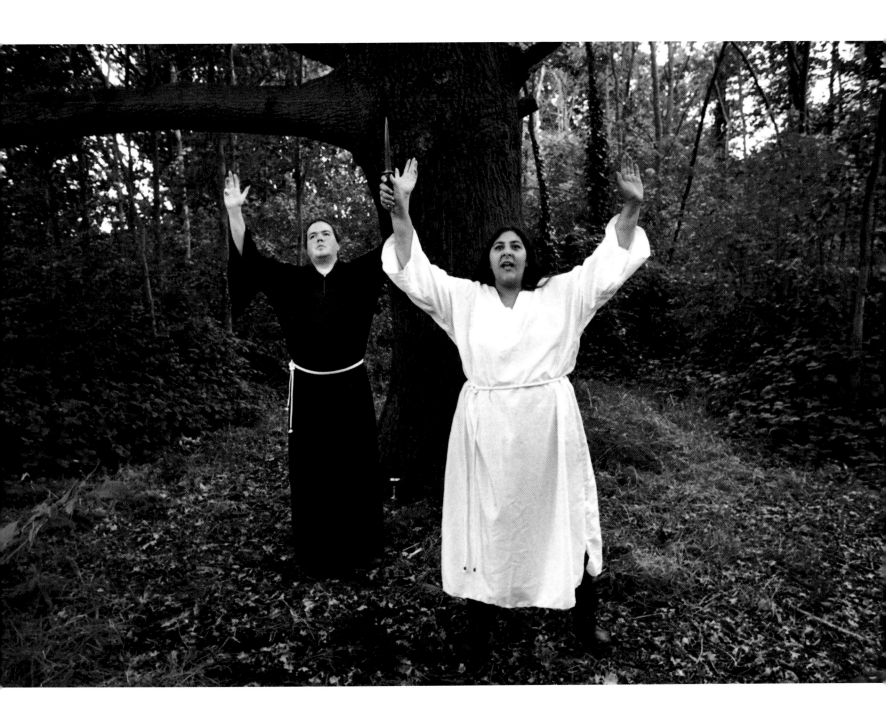

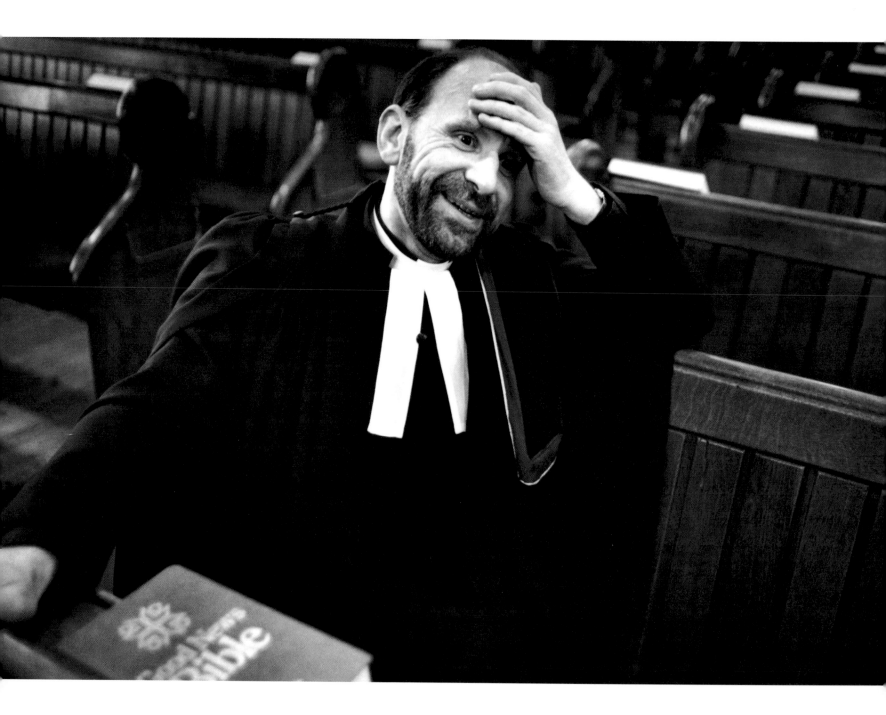

Rev. Barry Boyd,

Church of Scotland,
in St. Laurence Church,
Moray, Scotland.

Very often, people are caught between what the mind tells them and what the heart wants. People have an emotional call to something deeper and more meaningful in their life but their logic goes against that. How do you know your husband loves you? You can't define it by the flowers he gives you - it's just something you know, it's instinctive. As long as we keep trying to deny faith by reason, we will never resolve the conflict. Faith can only be caught by taking an emotional risk. All relationships are about risk.

But it's bizarre to think that faith can save us from our emotions and that we will never know sorrow again - there is no biblical evidence for that whatsoever. Laughter goes with tears in the anvil of life, and belief in God simply makes living easier. The call of faith is to get the best out of life in whatever circumstances we find ourselves. If we don't, it's a denial of God's gift of life, and that, to me, is a great pity.

Deirdre Pickering,

Buddhist (Soka Gakkai United Kingdom),
chanting at home with her husband,
Banbury, Oxfordshire.

We first met with the Buddhism of Nichiren Daishonin (the Japanese Buddhist prophet) when my sister started practising some twenty years ago. My first reaction was quite negative, but gradually I recognized a real and beneficial change in her.

A few years later, and my already waning Christian faith was not supplying the answers or support I sought. At this time I was seeing quite a lot of my sister. On an impulse - in fact the result of a gradual assimilation of Buddhist philosophy, I knelt and began chanting 'nam-myoho-renge-kyo'. The effect, for me, was immediate. It was like plunging into icy cold water and awakening every part of my being. Soon after, my husband joined me in the practice, together with my three, now adult, daughters.

We find it a means of daily revitalization and of putting ourselves into rhythm with the eternal and inherent mystic law of life, in order to pursue our lives in the most positive way, for ourselves and others.

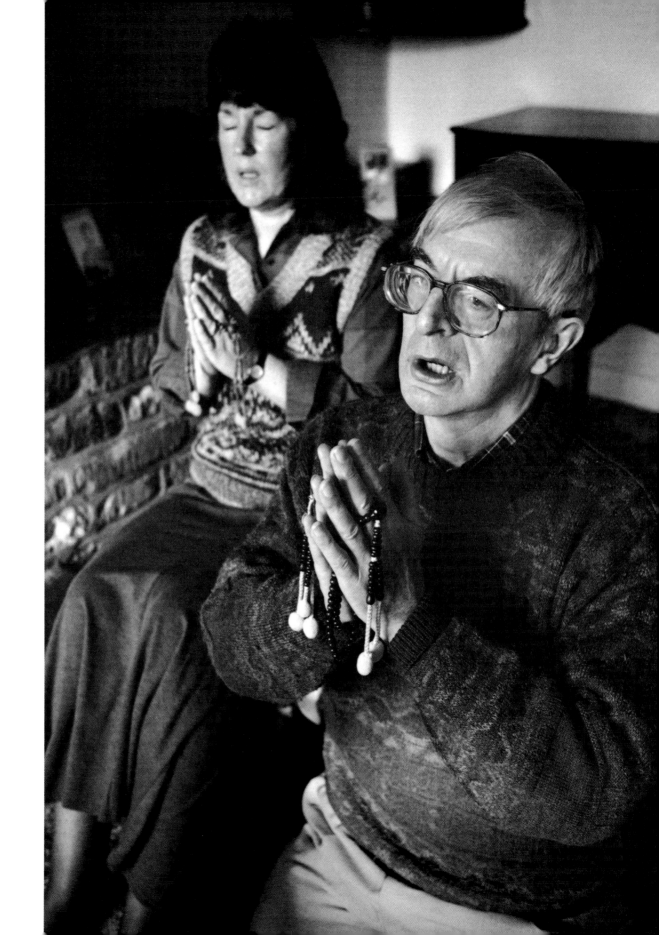

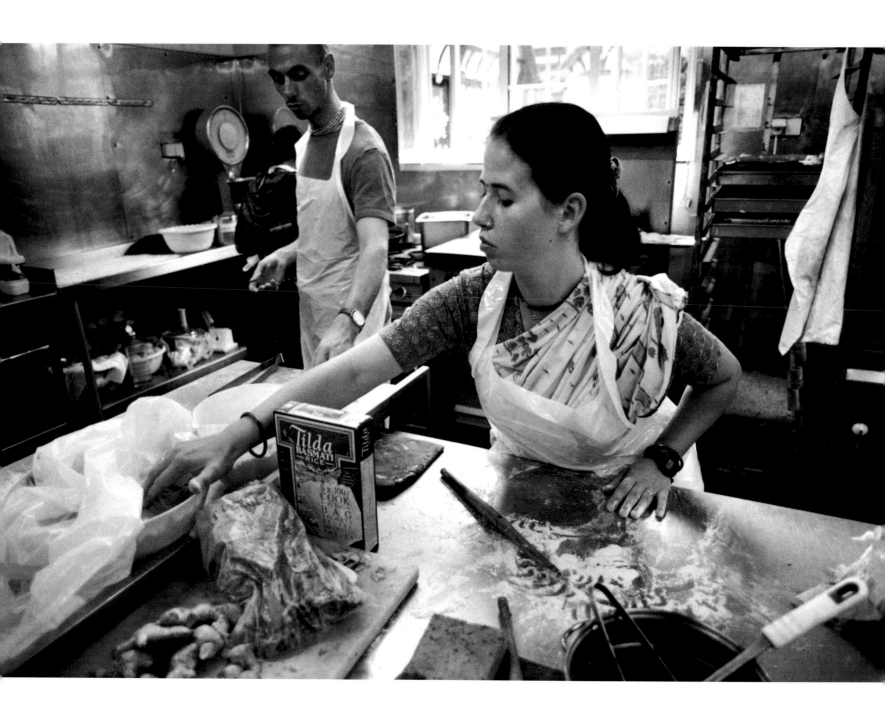

Brasmati Devi Dasi,

Hindu (International Society for Krishna
Consciousness or Hare Krishna),
preparing the community's meal,
Bhaktivedanta Manor,
Hertfordshire.

When I was a teenager, I didn't fit into materialistic society, and I was
forced to look for something deeper, something spiritual. My parents
wanted me to go to university and later to get a proper job, but for me
there was no sense in such a lifestyle. When I met some Hare Krishna
devotees, they told me about the four principles: no meat eating, no
intoxication, no sex outside marriage and no gambling.

Devotional service, another aspect of ISKCON, means work done
with love for the Supreme Personality of the Godhead Krishna. Every
devotee in the community does some devotional service. During the
day, the temple looks like a beehive, some doing cooking, some clean-
ing, some worshipping the Deities.

My favourite duty is cooking. Everything we cook has to be offered
to Krishna, and then we can eat it afterwards. This food is called
'prasadam' – Krishna's mercy. If we have to offer what we cook, then
our consciousness while cooking has to be focussed on Krishna. Where
the consciousness is good, then that energy is going into the food. Our
movement is well-known for its good food – it's often called a 'kitchen
religion'. The food purifies and elevates one's consciousness to God-
consciousness – this is one of ISKCON's secret weapons!

Heidi Therese Fageraas,

Elim Pentecostal,
at Sunday Service,
Kensington Temple,
London.

I was born in Norway in 1969 into a non-religious family. As a child I used to attend a local Christian summer camp where I began to learn about who Jesus was, and what he had done for me by dying on the cross. One evening at the camp, I decided that it was time to meet him. I began to speak to him in prayer, and asked him to forgive my sins and cause me to be born again as his child. As I prayed, peace and joy suddenly began to flood my whole being, and I felt free, pure and forgiven.

Later on, while at theological college in Oslo, I came across a group of Pentecostals. I witnessed the fact that Jesus was still doing the same things he did in the Bible, healing the physically and emotionally sick, binding up the broken hearted and saving those in slavery to sin. I heard about Kensington Temple, which ministers to over 13,000 people in London, and I left Norway to spend some time in their Bible school.

A service at KT is a marvellous experience of joy, gospel singing and hot power preaching. Although the ministers who preach have theological degrees from British universities, their simple, forthright style attracts people from all over the world to hear the sermons. During worship, it can feel like heaven is descending to earth, the Holy Spirit seems to sweep us into the reality of the presence of Jesus. The whole of our worship proclaims and seeks to demonstrate that Jesus is alive and working amongst his people today.

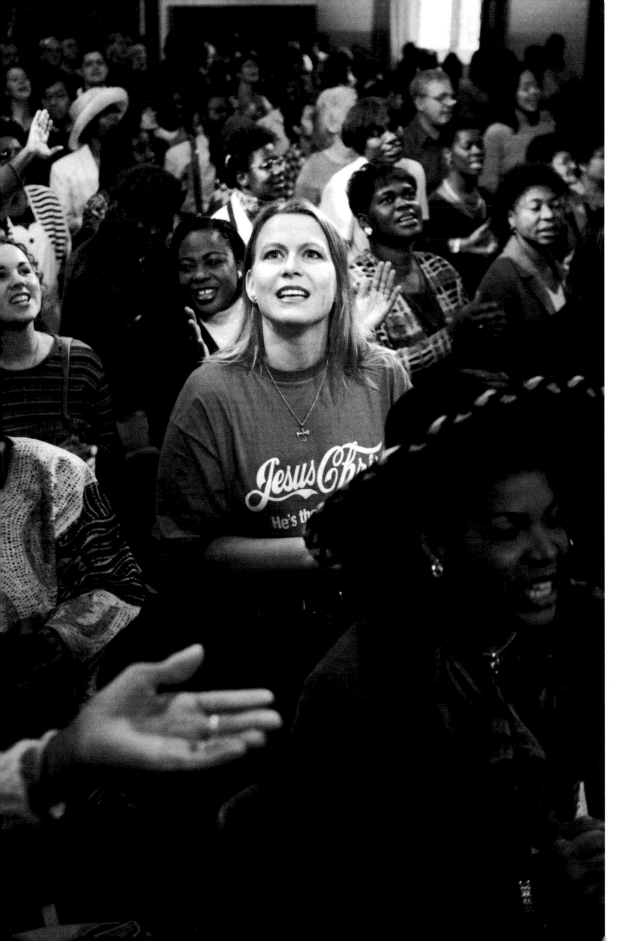

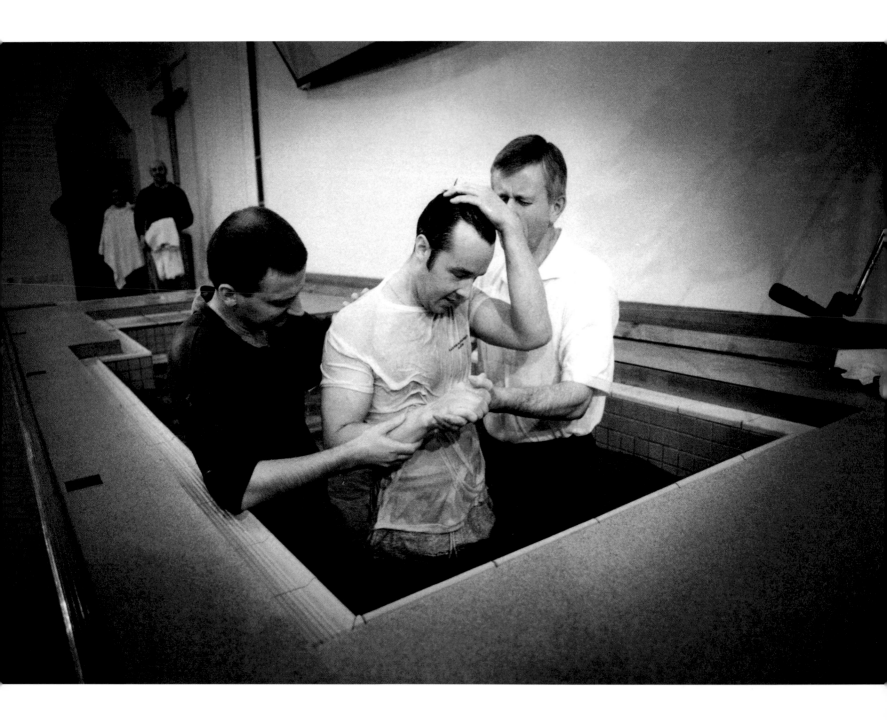

Craig Hynett,

Baptist,
at his baptism,
Sutton Coldfield Baptist Church,
Sutton Coldfield,
West Midlands.

A friend of mine, Chris, led me to the Lord, due to a lot of mental pain I was going through, as he himself had been through. He said, 'Craig, the Lord can set you free', and I said, 'Yeah, right Chris', thinking he was mad, I suppose. But I started to go to a fellowship which Chris had set up, and I was prayed over countless times, which was strange and uncomfortable, if I'm honest. The mental pain was getting unbearable, so I really started to cry out to the Lord to set me free if He was really there. Then one night I walked out of the church – I don't know when it had happened, but the Lord had set me free. My eyes were enlightened by God's love, grace and mercy. I'd found the meaning and purpose to life.

I look back now and I realize the Lord had to break me down for me to cry out to Him. I'm a living example of how the Lord is still today changing peoples' lives.

Rabbi Louis Jacobs,

Jewish (Masorti),
at New London Synagogue,
London.

It may be evidence of superficiality, but I have never doubted the existence of God. Nor have I had any reason to question the basic beliefs of my religion, Judaism, though here I have found problems. I do not believe, for instance, that everything that goes by the name of Judaism is true or that there is no truth in other religions.

I know that my religion has come down to us through human beings - great men indeed - but being human, prone to error. This has resulted in an attitude of openness to new knowledge and in my stressing the idea of a quest: we are all on a quest, as I see it, in search of God. As a rabbi, I teach and practise my religion, but I am aware that not everything in it has been dictated by God. Nevertheless, I have sufficient confidence in it and sufficient faith in God to believe that I am on the right road. In my view, all religious people are embarked on a great journey to God, with the way mapped out only in broad outline.

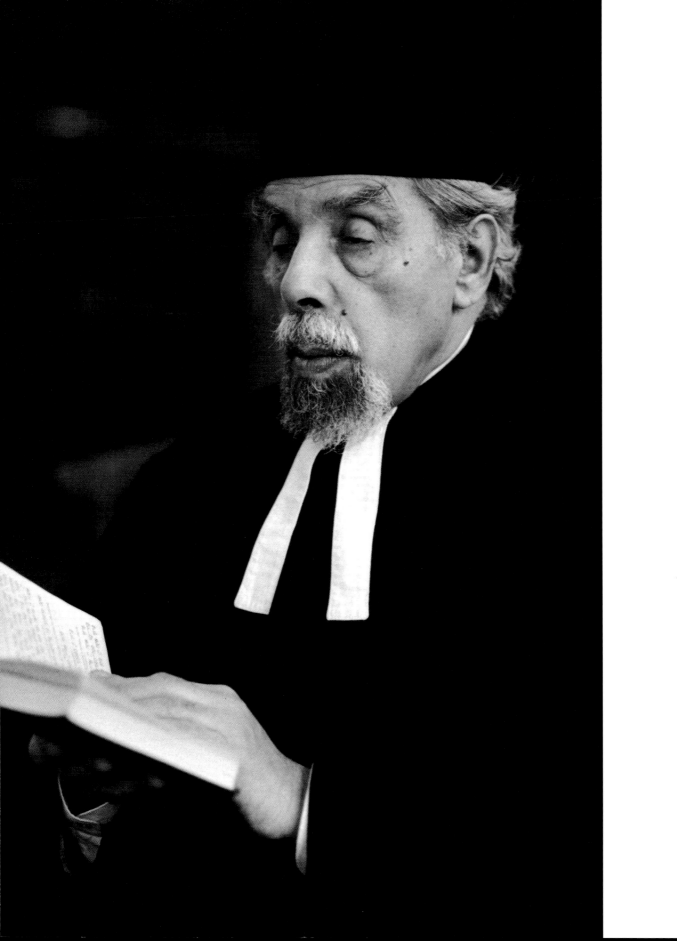

Jennifer Teo-Grist,

Buddhist,
celebrating the Chinese New Year,
at the Fo Kuang Shan Temple,
London.

New Year is a very important time for the Chinese. We pray to the Buddha for a happy and healthy year to come. I hope this year will be better than last! Last year I spent so much time helping in the temple that my husband, who is English and not a Buddhist, got very upset. He said I was not spending enough time with him. I felt very torn and very upset. I turned to one of the nuns at the temple for advice, and she said, 'Let go of the problem. A solution will come to you. If something is meant to be part of you, it will be yours, don't force it.' Gradually I started to do fewer duties in the temple, and now we are all happy, because I can still go there once a month, and the other times I can be with my husband.

At home each day I rise at 4.30 a.m..and I do my lesson for half an hour. The house is nice and quiet and I feel fresh. I light a candle and some incense, and I read the Diamond Sutra, one of the Buddha's lessons on how to live life. He teaches us to 'put things down' and not to take everything into our hearts, and to be calm and at peace as we go through our life.

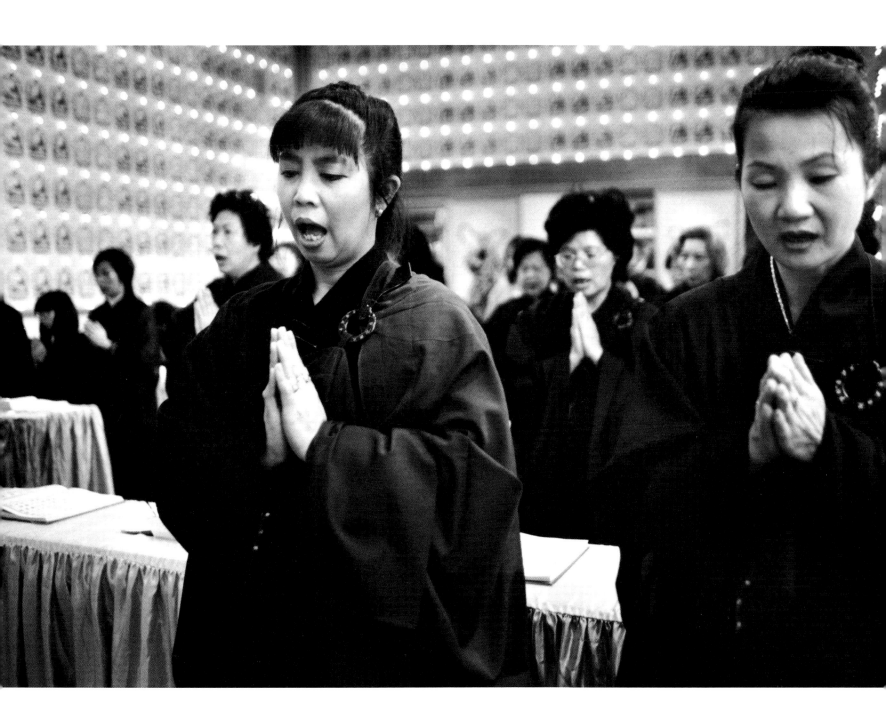

Sister Mary Joseph,

Catholic nun (Benedictine),
Tyburn Convent,
taking exercise,
London.

After getting a law degree and then a job in a law firm, I made my first ever pilgrimage to Lourdes, a French shrine of Mary the Mother of Jesus. It was there that I began to realize God's presence in the world and his love for us all. After that, I started going to daily Mass, and my attraction to work for and in the Church grew and grew, and eventually that is what led me here.

In the monastery, our work is principally that of prayer. We rise each day at 5.00 a.m., to sing the Liturgy of the Hours – the official prayer of the Church – which we sing seven times throughout the day, ending at 8.45 p.m. We also pray privately in turns, in the chapel, both day and night, for the Pope, the Church, our country and the whole world. My parish priest says that here at Tyburn we pray for 'a world that no longer knows how to pray for itself'.

When I'm not praying, I work in the monastery kitchen, making the evening meal for the community and our guests in the guesthouse, and then what with lessons, bible study, choir practice, and conferences, the day is full, varied and very fulfilling. I consider it a great gift to live in a house of God, praying for the needs of the world.

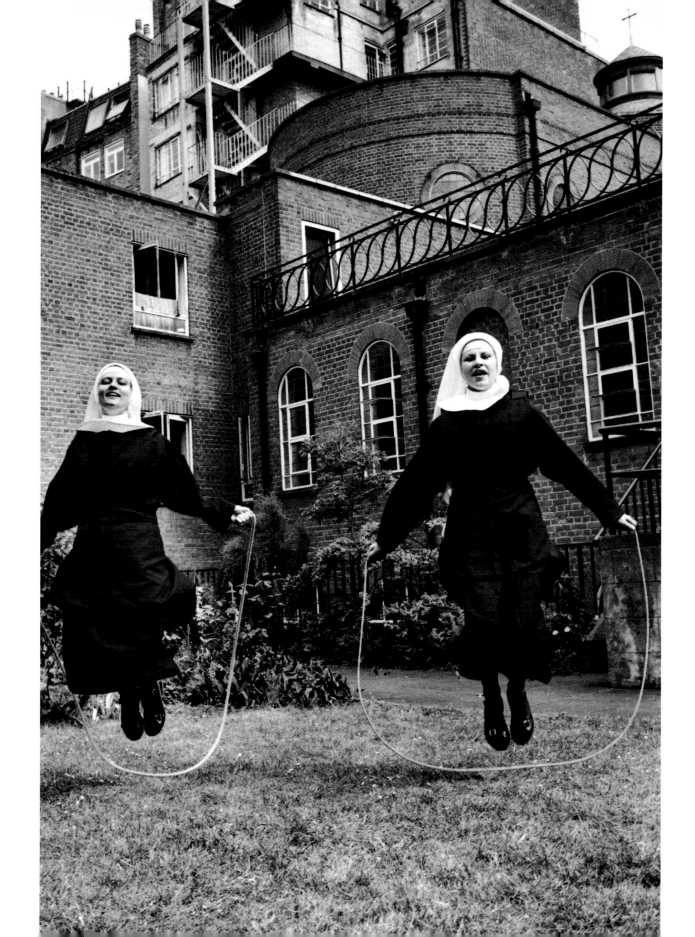

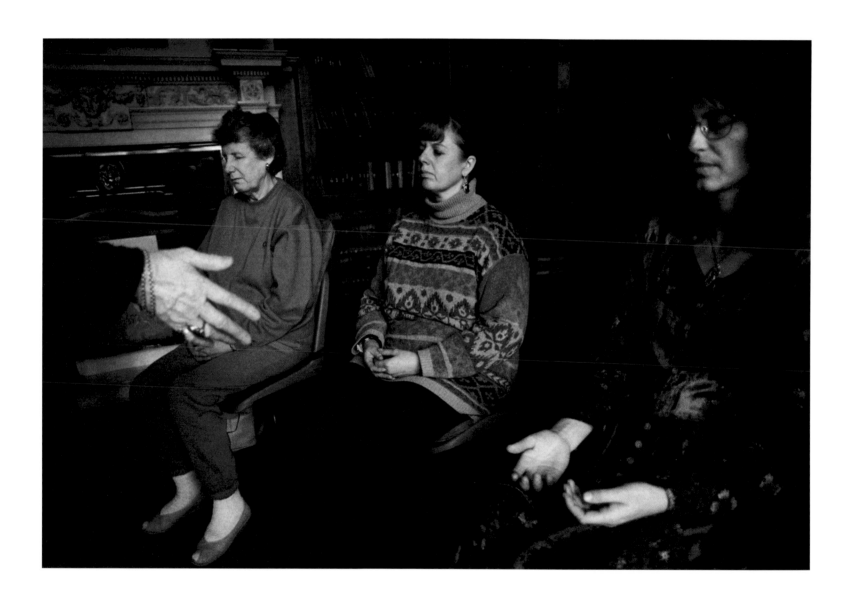

Susie Bull,

Spiritualist,
at Morning Power practice,
Arthur Findlay College,
Stansted, Essex.

This picture of me was taken during a course I was attending on Spiritualism and Trance States. That morning we were in a group meditation, in which we would sit in and blend with the Power of God, inviting the Spirit World to work with us.

I cannot imagine how I would feel if I did not have a firm belief in the continuing existence of the Soul after physical death. It has certainly helped me to accept the death of family and friends in a much more natural way. I can now view these partings as temporary and although there is sadness and pain there is also joy and a feeling of celebration that the Soul of the loved one has returned home to God and continues to exist. Furthermore, come the time for my own departure, it is a great comfort to know that I will step across into the World of Spirit and be re-united with those who have gone before.

Canon David Adam,

Anglican,
Vicar of Holy Island (Lindisfarne),
Northumberland.

Out of what has been, new life comes:

What is to be is created from the old:

To the old, new vision, newness of life calls.

Ruin hopes, ruin dreams, ruin buildings are rebuilt

Lives for ever interweave and enrich each other.

The Great Other who is God

Comes to us in the other that meets us.

No visitor is an interruption but an opportunity,

All meetings are encounters:

They ask for openness and acceptance.

We each become a doorway for God

To enter the other's life.

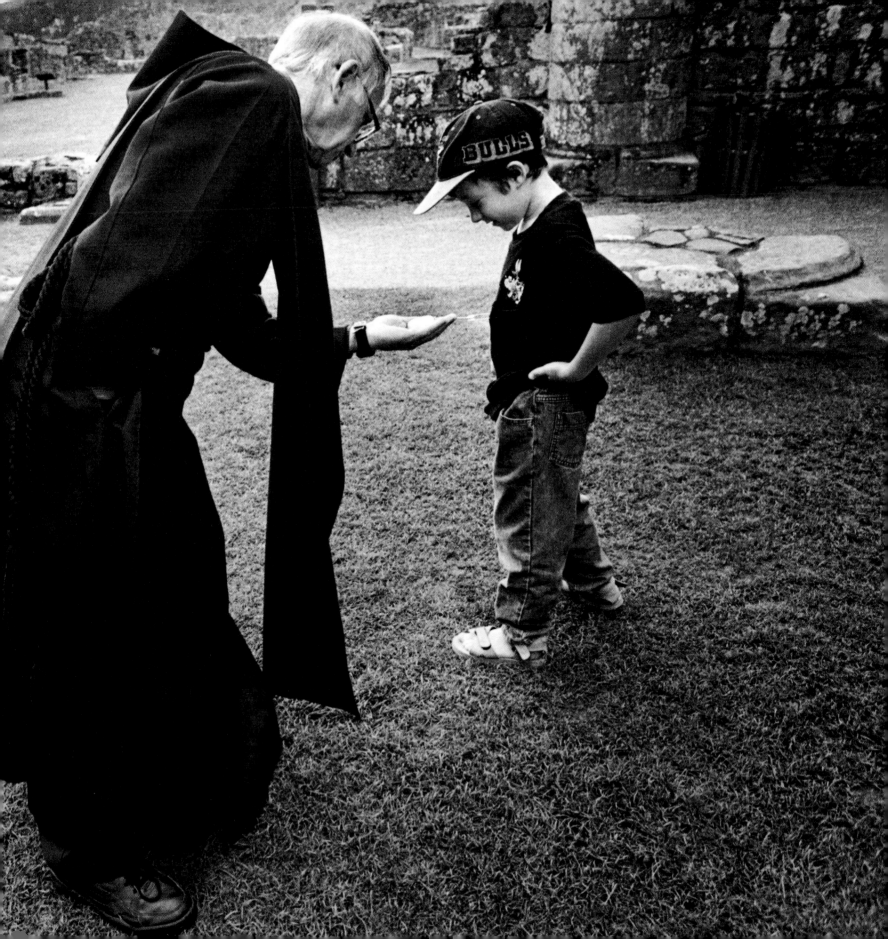

Jehaan Bhatia,

Ismaili Muslim,
at a wedding at Ismaili Centre,
London.

When I was asked to recite an extract of the Qur'an at my cousin's wedding, I felt very honoured. I believe the material and the spiritual worlds complement each other – although it is hard to spend enough time on the spiritual, what with academic work, practising my music and going out with my friends.

My religion gives me a direction in life. It gives me a meaning instead of life just being about worthless existence. The Ismaili community also offers tremendous support, acting as an extended family, and I gain a lot of experience doing voluntary service. Finding the balance between the religious and the material aspects of my life is a challenge, but I would not want my life any other way.

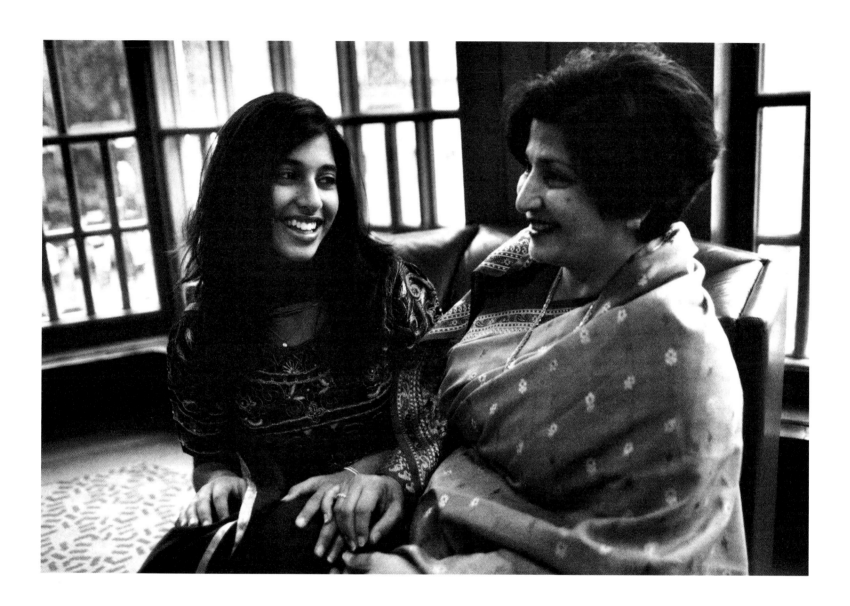

Meera Thakkar,
Hindu,
offering Arti (worship)
at Shri Jalaram Prathna Mandal (Temple),
Leicester.

I was born in England, and I am proud to be English. There is another part of me, though, which is Hindu, and I am equally proud of that. It is the religion of my ancestors, and I hope my children will carry it on.

Hinduism is a very interesting and complicated religion. We have a number of Gods and Goddesses whom we worship - Lord Rama and Lord Vishnu are two of the most important.

We celebrate New Year by going to the temple and offering *arti* to the Gods and Goddesses, and we give them sweets that we have prepared, and then we sit down and pray. After we have been to the temple, the whole family gets together and we have a big feast. In the evening we have *Chopra Poojan*, which is a religious ceremony where the old financial books are closed and the New Year books are opened. It is a ceremony for Lord Ganesh to bless all in the New Year.

Ras Seymour Mclean,

Rastafari,
studying the Ethiopian Bible,
Camberwell, London.

Ras Tafari Mekonnen (also known as Haile Selassie I) was born on 23 July 1892. On 2 November he was crowned 'King of Kings', 'Conquering Lion of Judah', Emperor of Ethiopia, and the ceremony was attended by all the Great Powers and royal families in the world.

Jesus Christ promised that when he returned he would be a 'King of Kings'. We believe that Jesus Christ revealed himself in the personality of Haile Selassie I. He is the fulfilment of the prophesies in *Revelations* Chapters 5, 17 and 19, and by his works as King we know him to be the Second Coming.

The Emperor published the first standard Ethiopian Bible in 1961, and in this picture I am reading the Psalms of David in Amharic, the Ethiopian language.

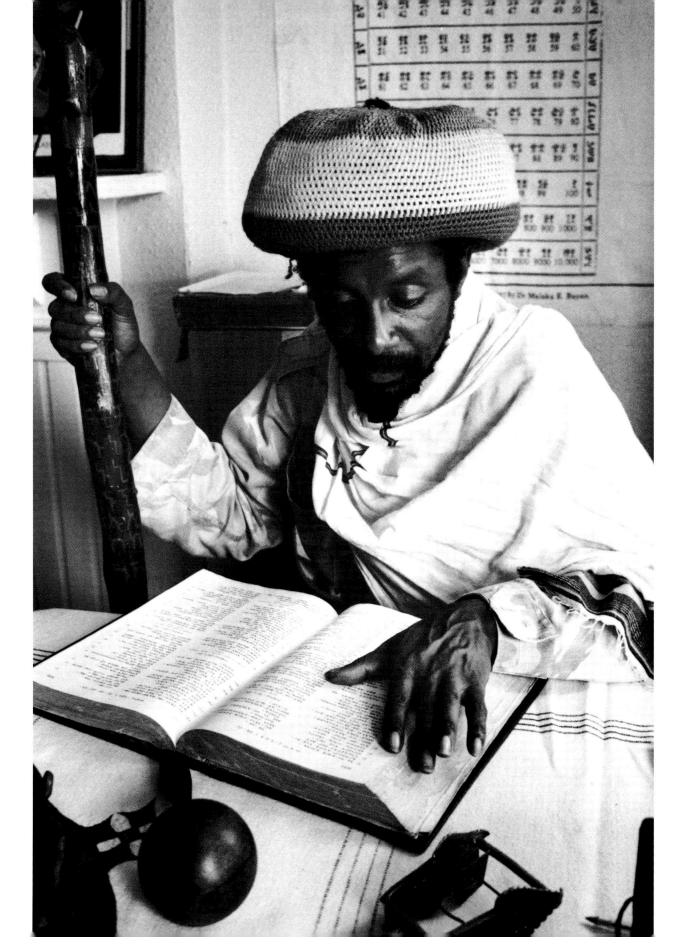

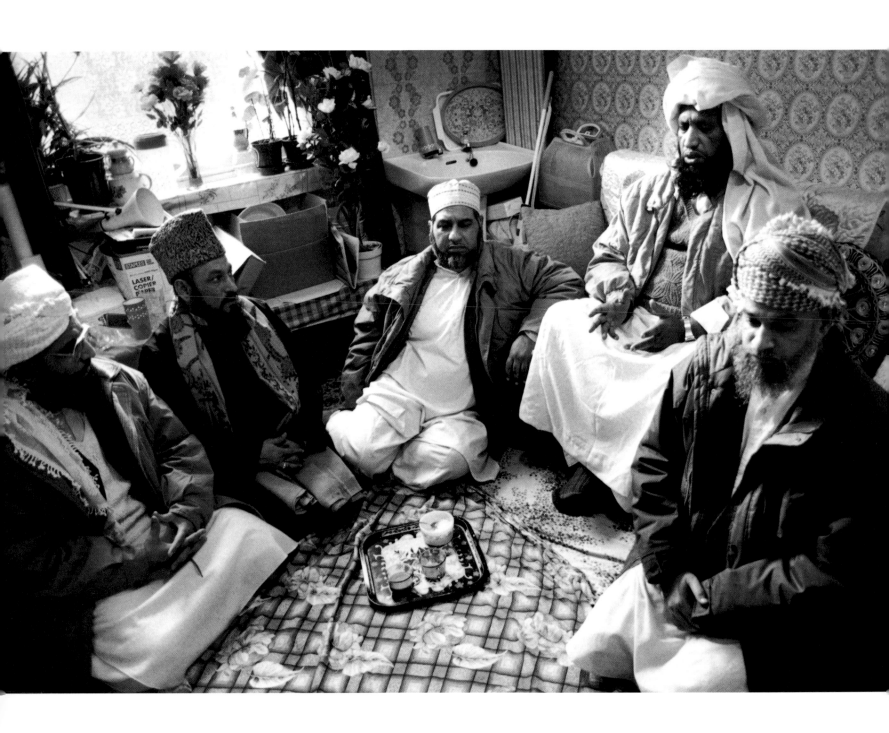

Pir Mahroof Hussain Shah,

Sufi Muslim Sheikh,
in discussion at his home,
Bradford.

The Qur'an reminds us to 'Seek help through patience and prayer for God is with those who are patient.'

I was born into a Muslim family, and my parents taught me the Muslim way of life from my early childhood. My faith strengthened further once I was able to think for myself. I came to the conclusion that life was not just about eating, drinking, sleeping, work, rest and play; it was also about developing inner self and knowledge or spirituality; to better oneself as well as others by following the Qur'an (Holy Book), and the Sunnah (practices of the Prophet Muhammad - peace and blessings of Allah be upon him).

I also realized that I was on a journey – it was from God that I have come and one day I shall return to Him; that I will be held accountable for what I do here on earth when I return to Him. The benefits, rewards and happiness in the next life are countless compared with those I get in my short life on earth. I therefore have a duty to obey and please God, even if this is against my desire or I have to suffer hardships and difficulties to please Him.

Rev. Graham Kent,

Methodist,
reading the Scriptures,
the Octagonal Chapel,
Heptonstall, West Yorkshire.

I am a Christian because it seems the natural, proper thing to be. We are all made to discover a loving relationship and working partnership with God: faith in Jesus Christ is about being radically and truly human. The lives of Christians I know and the Saints of earlier generations convince me that His spirit is working amongst people and I want to be included.

Full-time ordained ministry in the church of my childhood years is the means for me to fulfill God's call. The Methodist way has never excluded, but has always had an ethos of democracy and non-hierarchy which is 'of the Gospel'. We have a coming together of dignity and informality, scholarship and common sense, discipline and freedom. Our heritage is one of seeking to serve God in each generation on a journey to holiness, our ultimate and promised goal.

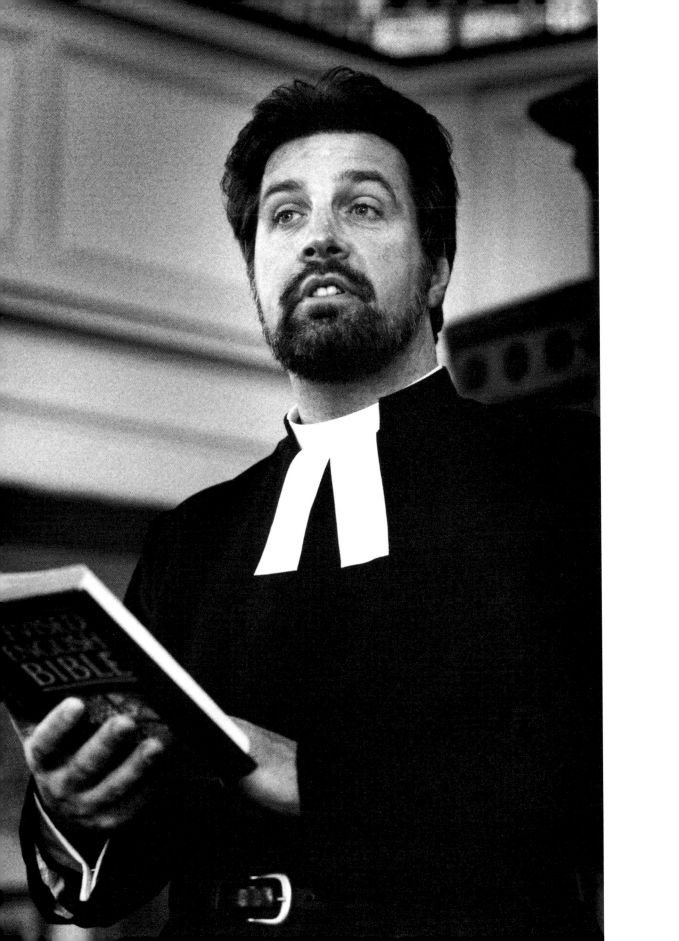

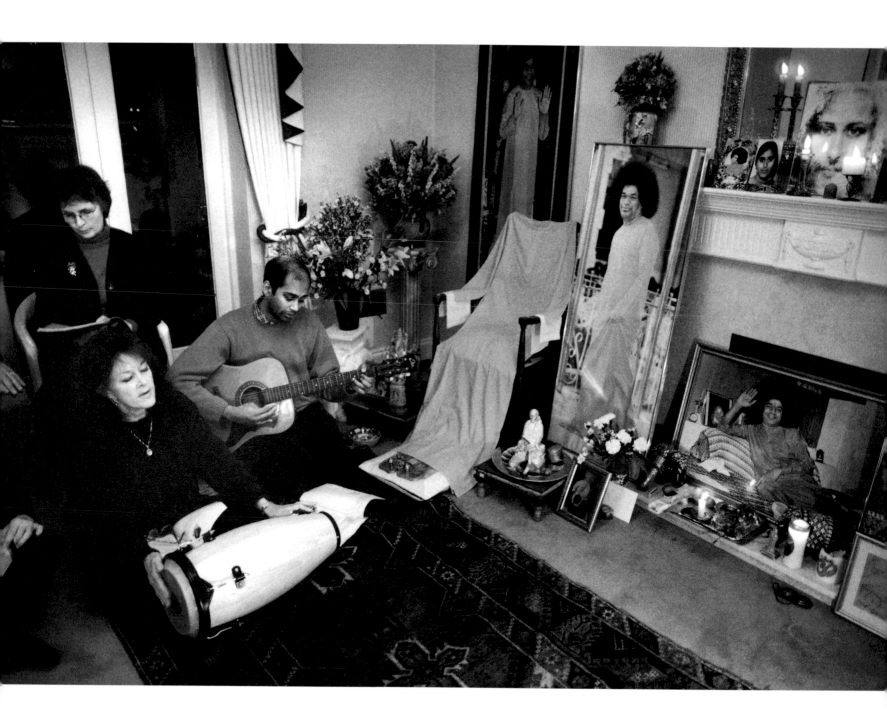

Linda Bond,

devotee of Sai Baba,
performing Bhajan (devotional singing),
Bath.

Sai Baba is an avatar (descent of God into human form). When he was 21, he outlined what his life purpose was: 'I have a task: to foster all mankind and ensure for all of them lives of Ananda (bliss). I have a vow: to lead all who stray away from the straight path back into goodness and save them. I am attached to a work that I love: to remove the sufferings of the poor and grant them what they lack. I have a reason to be proud: for I rescue all who worship and adore me.'

Swami Sai Baba's teachings are simple: to help individuals to be aware of the Divinity that is inherent in them and to conduct themselves accordingly and to practise, in daily life, divine love and perfection and therefore to fill one's life with joy, harmony, beauty and grace.

Sai Baba says that his teaching is not a new religion, but that it makes the devotees of the spiritual path more sincere by introducing love into every aspect of life, by seeing the essential unity of all religions, by looking at all work as service dedicated to the Divine and by looking at all beings as manifestations of Divinity.

Jonathan Prendergast,

Seventh Day Adventist,
attending Divine Service at Brixton
Seventh Day Adventist Church,
London.

I grew up in an Adventist Christian home. What impressed me when I was a child was the picture of Heaven, where the lion lay down with the lamb and the angel sang praises to God on high. There was a peace that attracted me to that place.

My parents taught me that God is love – and I know how my parents showed me love. I learnt that God sent his son Christ to pay the cost of death and set humankind free, and restore it back to Paradise lost. To me this was a miracle of love, and a promise that once again the lion will lie down with the lamb.

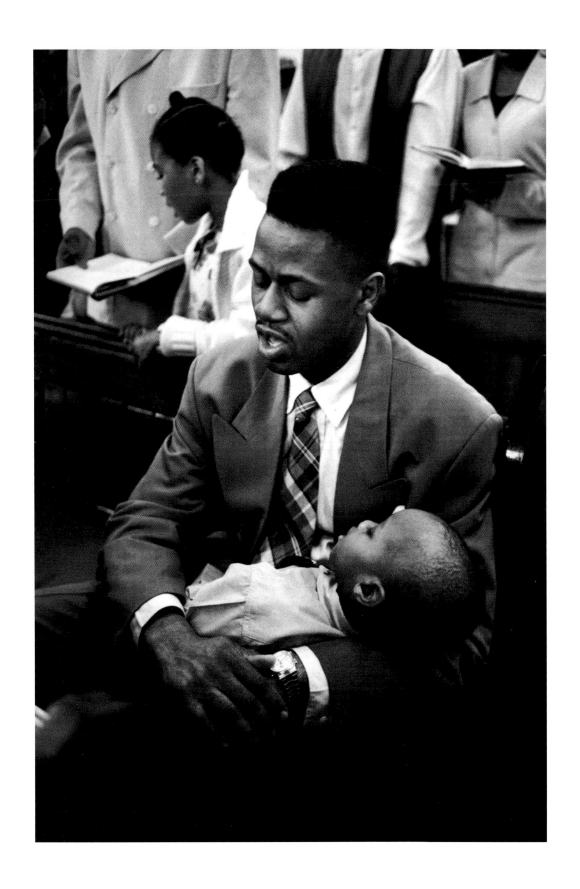

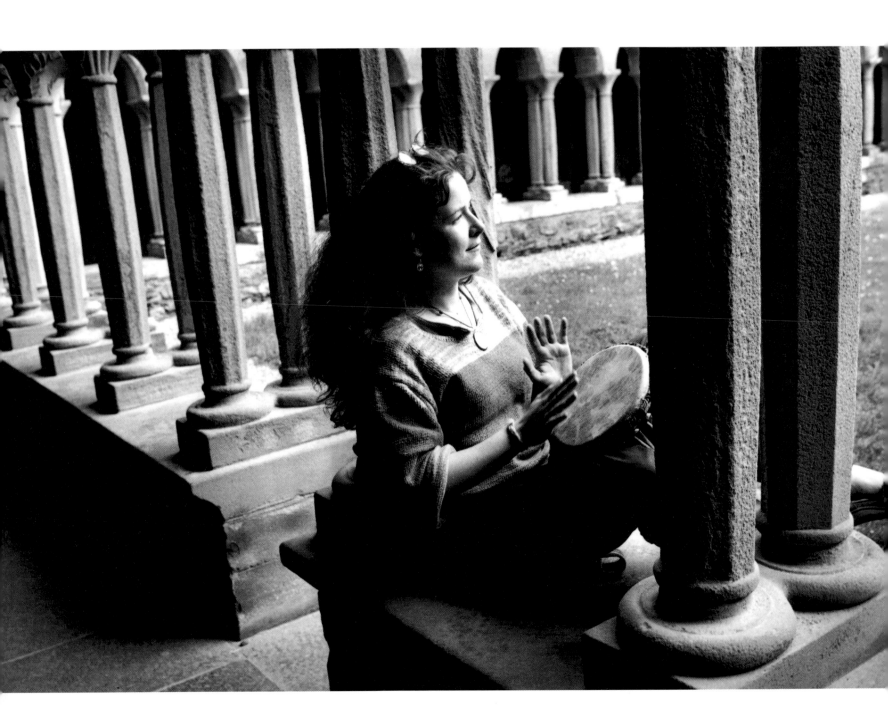

Jane Bentley,

Christian,
one of the Iona Community,
in the cloisters of Iona Abbey,
Iona, Scotland.

I was a devout church-goer as a child, but as teenage years approached and I began to form my own questions, I became rather disillusioned with the Church, and gradually drifted away from it. God was always there though, and as I matured, I began looking at other faiths and lifestyles, dipping into each as I saw fit, but never settling for any particular belief.

I was first attracted to Iona through the idea of living in community, and also by the history of the place. The fact that it was a Christian community did worry me slightly – I had fleeting visions of being greeted with a big smile and an 'Are you saved?' Despite these reservations, I signed up for six weeks voluntary work...

And I love it here, my preconceptions have been shattered. Here is a group of people, held together by their faith, and trying to make real sense of it, relating it to the world around, and living it out in daily life, concerned with peace, justice and global issues, as well as the day-to-day business of welcoming the guests that come and stay here, and building community together.

It has been wonderful for me to return to the faith I so loved as a child, and find out what it means to be an active, committed Christian, and yet still be able to learn from and respect the other great wisdom traditions of this world. I feel like the prodigal daughter!

Aziz Theo Dikeulias,

Sufi,
leading Dances of Universal Peace,
London Sufi Centre,
London.

Music and ecstatic dancing are used by the Sufis as tools for 'attunement'. They by-pass the conscious mind and help us to overcome the state of duality in which we think we live.

Ever since I was a teenager, having been brought up in the Greek Orthodox tradition, I remember wondering what would have happened to me had I been born into, say, a Muslim family instead of a Christian one. Jesus said, 'I am the Way and the Truth' – would I be condemned even though I might be a good man? This didn't make any sense to me. Is there more than one Paradise? I remember agonizing over this question and there was nobody in my life who could answer it.

When I discovered Sufism, I found confirmation of a deep-rooted conviction I've always had that all religions try to contact the same being. There are different names, rituals, languages, as one would expect, even different teachings according to humanity's needs and evolution at a given time, but, ultimately, there is only one God.

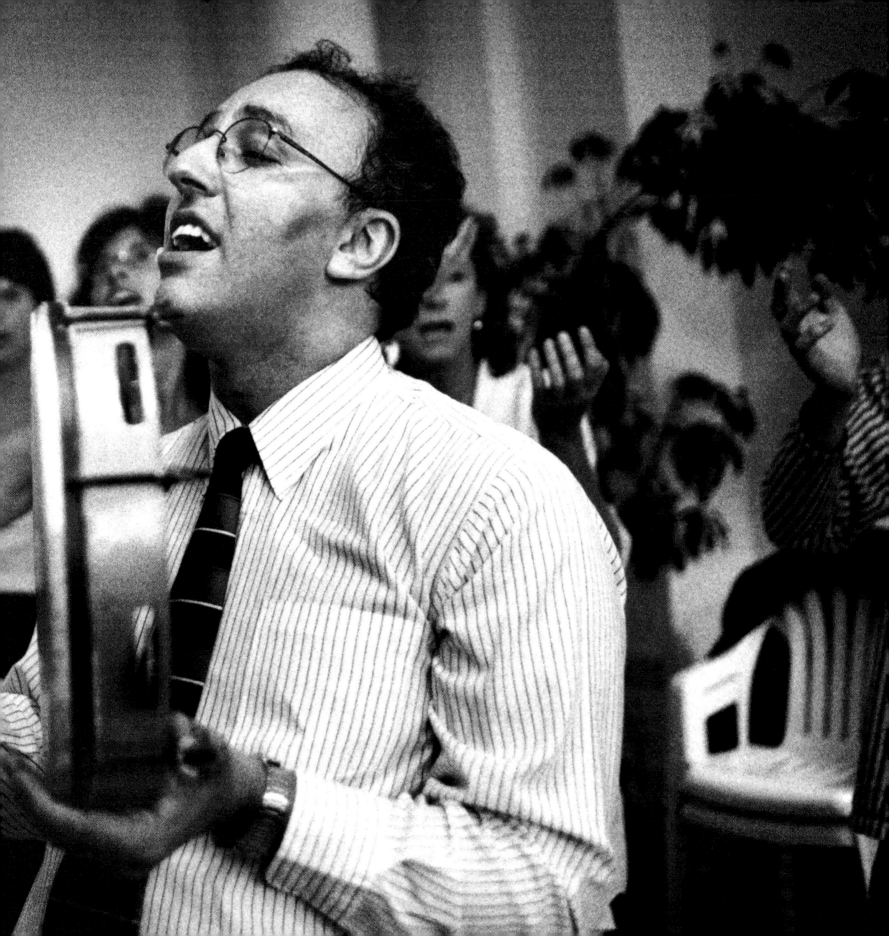

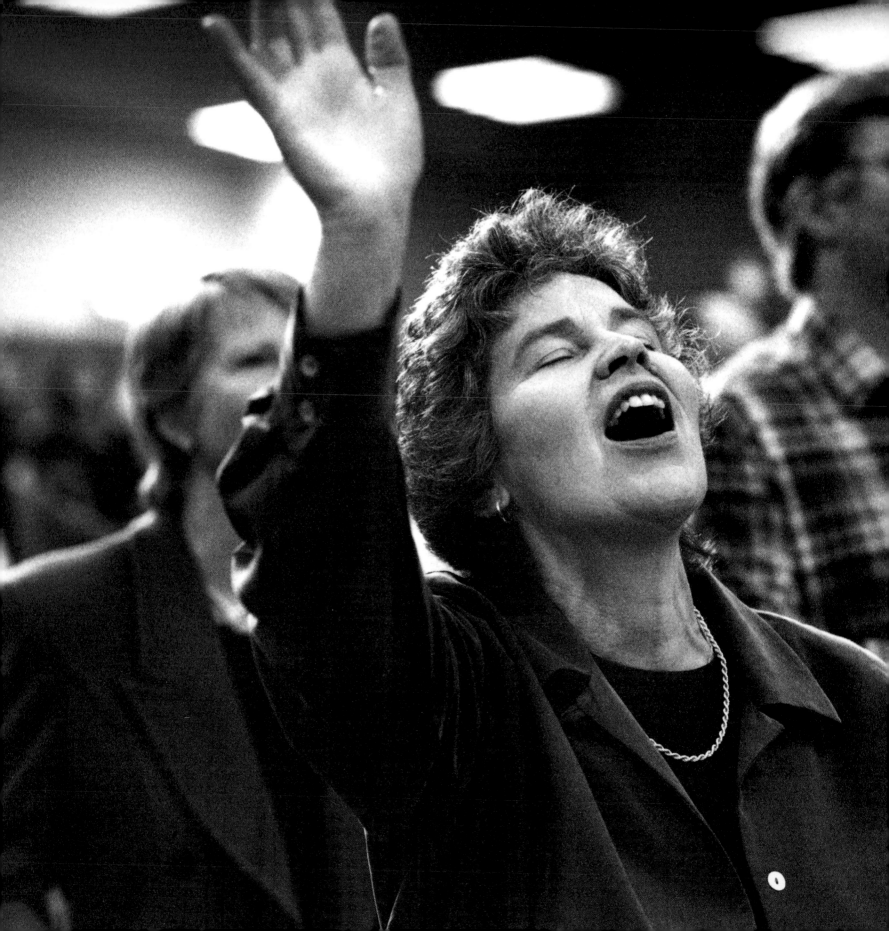

Caroline Urquhart,

Kingdom Faith Church
(Independent, Charismatic Church),
on Easter Sunday,
Horsham, Sussex.

Easter Sunday is always a reminder of the fact that Jesus Christ, the Son of God, died on the cross for my sins, which separated me from God, and rose again into heaven so that I can have a relationship with Him.

I became a Christian 24 years ago when I was an Anglican (my husband was the vicar). The church we belong to now – my husband is the pastor - is Charismatic and we have around 1,000 members. Together we praise God and pray to Him, expecting Him to heal people and change their lives. My life has changed radically as a result of my relationship with God, and my family has changed also, including two of my children who were physically healed when they were younger.

Worship for me is a way of drawing close to God and expressing my love for Him, getting to know Him and His ways more. As I worship it is easier to hear Him speaking to me. He is continually transforming me and working for my good.

Jamie Scott,

pupil of the Maharishi School of
the Age of Enlightenment
(Transcendental Meditation),
Skelmersdale, Lancashire.

Every day I go to school and start the day with ten minutes of Transcendental Meditation. TM is a scientifically proven mental technique which aids stress release and has many other benefits. This practice of TM helps to give me a calm settled feeling and clarity of mind which last throughout the day. Each day finishes with another ten minutes of TM before leaving school.

Our school day is not very different from that of any other school, except for our practice of TM twice daily, but learning is easier and creativity is boosted.

As TM is a simple mental technique which anyone can learn, it is not necessary to do or believe anything unusual in order to practise it.

Alan Goddard,

Christian,
leading an Alpha Course,
Bury St Edmunds,
Suffolk.

With the hunger in our society for spiritual significance, surely there must be an answer to the question, 'What is and where is the truth?' Over recent years, Nicky Gumbel, an Anglican minister, has developed The Alpha Course, which answers many of the questions asked: Who is Jesus? Why did Jesus die? What about prayer, healing and the Holy Spirit?

Anglican, Baptist, Methodist, and Independent Evangelical Churches have all adopted the Course to reach people who never have contact with a church. We now have some 6,350 churches involved. The Course lasts for 11 weeks, and each week we meet to listen to a talk, normally after a meal and a time for discussion.

The Course explores the meaning of life and the relevance Jesus has in our lives today. I get so much pleasure in seeing peoples' lives put back together by receiving forgiveness for past misdemeanours, and by achieving reconciliation in relationships. Through coming into a trusting relationship with Jesus Christ, people have a hope and a purpose in life they never thought possible before.

Judy Macpherson,

Christian Scientist,
in a Christian Science Reading Room,
Surrey

I once became very ill during a business trip. The company doctor diagnosed dysentery and prescribed some pills. As I was on company time, I took them, but only grew worse until I could not even retain a glass of water. I felt very miserable and alone.

Each day, I randomly opened the Bible and the Christian Science textbook, *Science and Health with Key to the Scriptures* by Mrs Eddy, and noticed a pattern forming. In particular, my *Science and Health* always fell open to the same page where these words were written: 'all being is eternal, spiritual, perfect, harmonious in every action. Let the perfect model be present in your thoughts instead of its demoralised opposite.'

Finally, I realized that I could not continue to serve two masters. I threw the pills away and turned to God with all my heart. I felt a change take place and I was instantaneously healed! I can't describe my joy! Feeling very hungry, I went to a steakhouse and ate an enormous meal with no ill effects.

The next day (a Sunday) was even more wonderful, when, in church, I heard every piece read out that had come to me while opening the books at random. I realized that right where I had felt so alone, God, my Father-Mother, had been with me, companioning and feeding me with all the spiritual nourishment I needed.

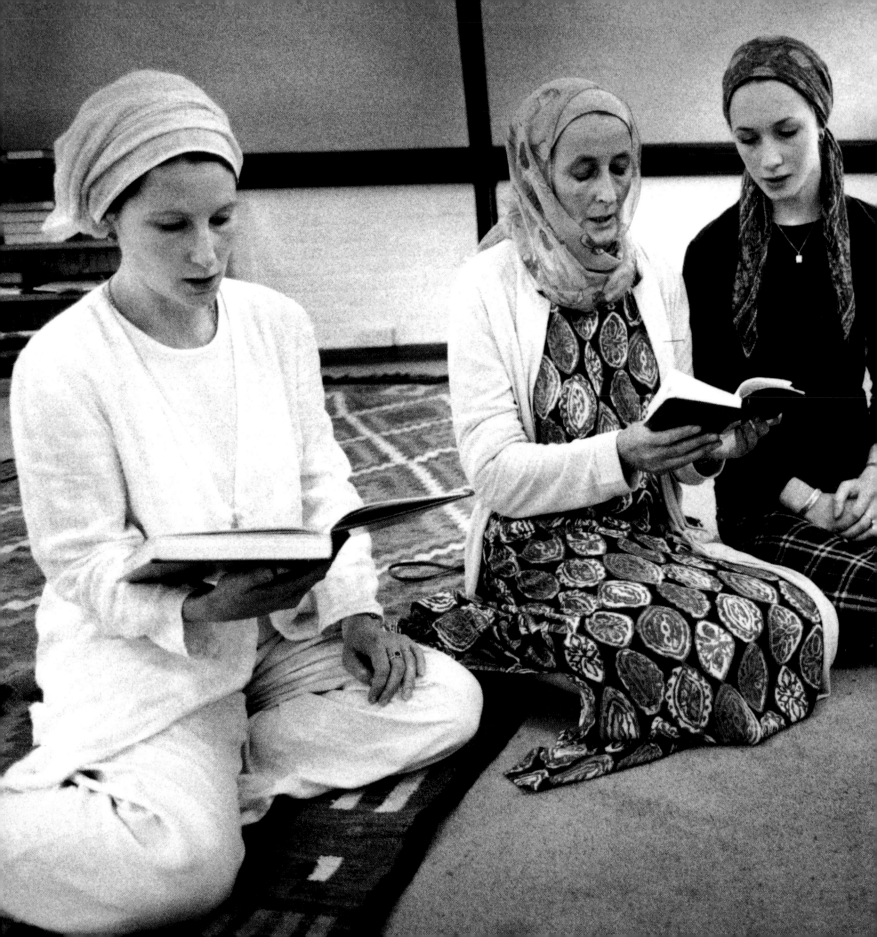

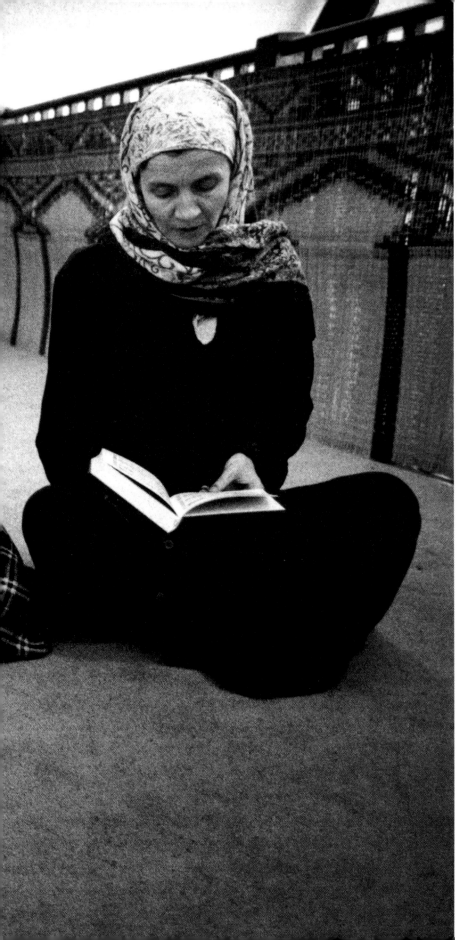

Mansurah Mears,

Muslim,
reading from the Qur'an
at the Ihsan Islamic Centre,
Norwich.

Becoming Muslim for me was an affirmation of the Truth, that is belief in God, which I had had since childhood but had been unable to act upon. Islam offered a way of life and a means of transforming the self which I had not found in the post-Christian materialistic society in which I grew up.

To some, the structure of Islam, which is in fact the key to inner spiritual freedom, will seem a strange phenomenon in an age of increasing outward freedom. Yet as we enter the 21st century, it is becoming clear to many that there is a natural form for mankind to follow (just as the rest of creation has a natural order) if we wish to reach our highest goal. For those who discover it, Islam comes like a cool refreshing draught of water slaking the thirst of the traveller and answering the question posed by God in the Qur'an, 'Where then are you going?'

Huda Abdel Malik,

Coptic Orthodox, at Communion service,
St Mark's Church,
Kensington, London.

In 1992 I went to Cairo to visit the head of the Coptic Church, Pope Shenouda. As a sign of my love for Jesus Christ, I was given a tattoo of the cross on my wrist. The pain was very bad for a few days. Anyone who sees this cross knows I am a Coptic Christian.

I wanted to be a nun, but I had to stay at home to look after my mother and father – they are both dead now, and I am too old to join a convent. I pray six times a day, at 6.30, 9, 12, 3, 6 and bed-time. My sister and I live together, and at prayer time we go into our bedrooms and pray with our prayer books for about half an hour.

On our wall going upstairs we have a very big crucifix. Whenever I look at it, it gives me a warm feeling in my heart, and it makes me happy.

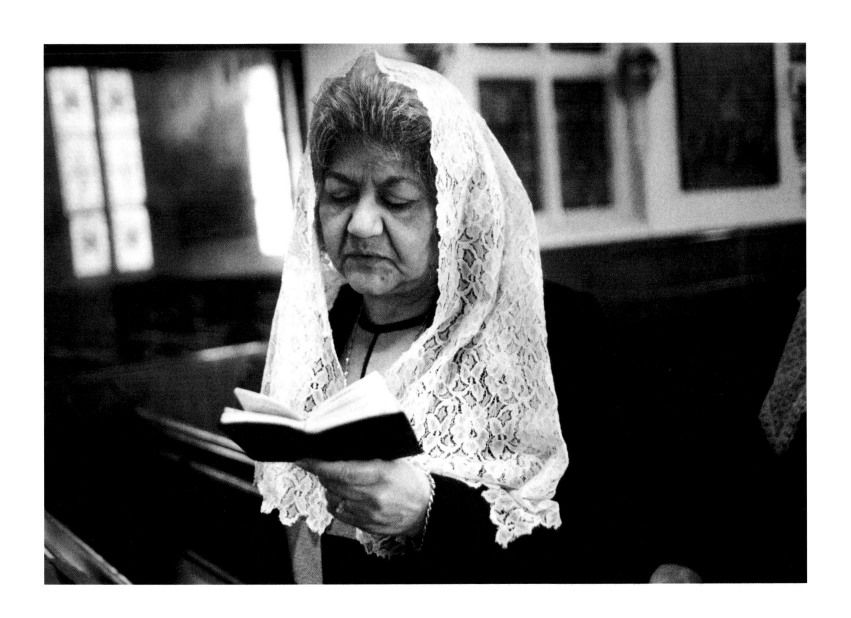

Captain Valerie Hope,

Salvation Army,
Christmas dinner for the homeless,
London.

I was born in the East End of London into a home where I was physically and sexually abused, consequently I was painfully shy.

When I was nine years old I went to the Salvation Army Sunday School, where for the first time I felt accepted and loved. I was told that Jesus loved me and wanted to be my friend - it seemed too good an offer to miss. My relationship with Jesus began and my life took a new direction. He became then, and still is, the first love of my life.

In my early teens I knew that God was calling me to share the Good News of the Gospel with others, and in 1966 I became a Salvation Army Officer. I meet many people with deep emotional needs, some turn to drink or drugs, I know I could have been among them. I know prostitutes who came from the same background as I did, I know I could be there but for God's grace in my life. I do not judge those I visit in prison because I could have gone that way.

Because God has healed so much of the hurts I experienced in my childhood, I no longer regret the past but thank God for it, because it helps me to empathize and understand the needs of those I have the privilege to work with. I know that what God has done for me He can do for anyone who seeks Him.

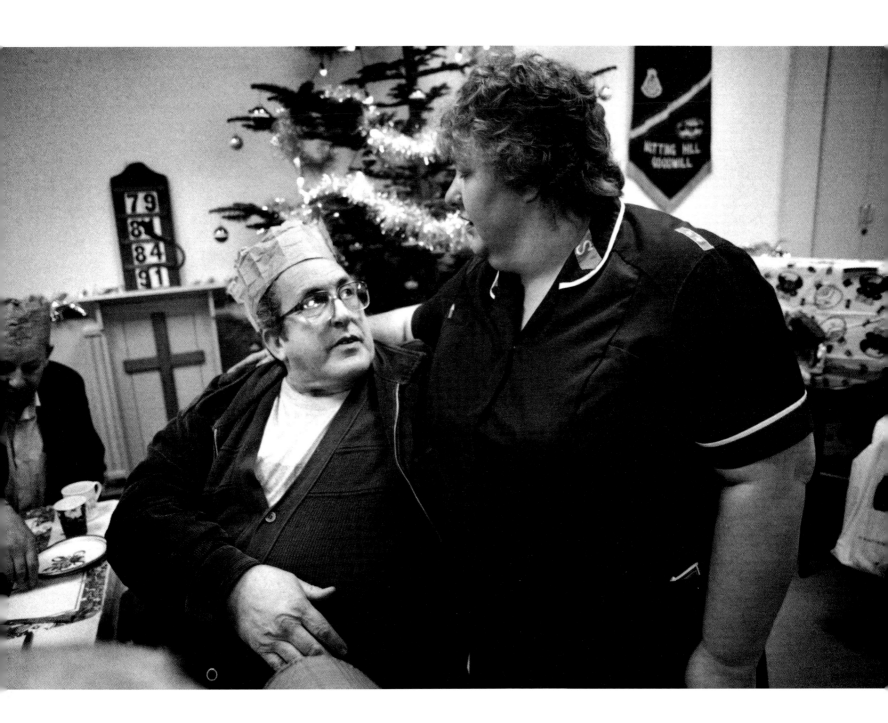

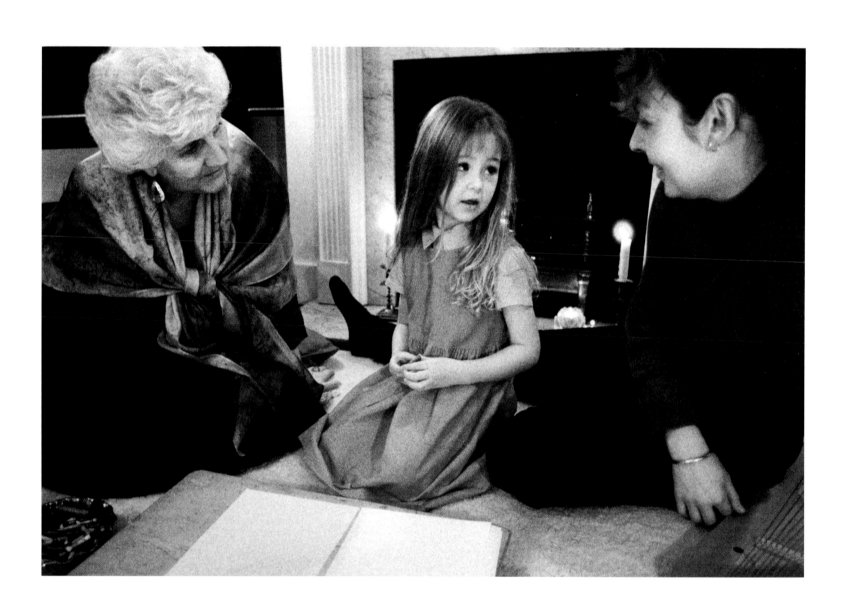

Marilyn Feldberg,

Psychosynthesis therapist, in a counselling session, London.

Described as 'psychology with a soul', psychosynthesis enables the integration of the personality in the service of the true Self of the individual; the Self in psychosynthesis is acknowledged as that which never changes and is a permanent source of wisdom and knowledge. It is a therapy which recognizes the importance of body, feelings, mind and spirit.

I see people of all ages. In this picture, I am working with a child, using drawing, music and storytelling in a creative play-session. These children of light need our love and support. We need to recognize and honour the true Self of the child.

Twelve years ago, I set up WYSE (World Youth Service and Enterprise), which uses psychosynthesis as its core model. We run international programmes for young people who have vision and awareness and are inspired to work towards a peaceful world. We help them to realize their creative potential, improve their relationships and define goals in order to be of service to their communities and ultimately to the world.

Darrell Williams,

Christian,
on the Walsingham Youth Pilgrimage,
Walsingham,
Norfolk.

I am fifteen years old and this was my first time on the Walsingham Pilgrimage. I had been visiting my brother in Liverpool. He was helping to organize a party from his church to go on the pilgrimage. Someone dropped out so I was asked if I would like to go. Would I!!! Another week with Mark, brilliant, was all I could think of. I never thought for one moment that I would get so much joy from the whole experience.

I thought the church services were brilliant, which surprised me, because worship had never meant so much to me before. Guitars, keyboards, even drums were used. The walk from the Slipper Chapel to the Shrine, where the photo was taken, was so enjoyable: the singing loud and joyful.

Most of all, the pilgrimage made me look at religion in a different way, and I even enjoy going to my own church now. When, near the end of the pilgrimage, I was rushed into hospital for an emergency operation, I was so scared and I wanted my parents. But the love I felt from all those on the pilgrimage filled me with peace. Hundreds of people prayed for me and I was told that everyone cheered during the service the next day when they knew that I was going to be OK. I felt blessed to have so many friends, and I can't wait to go to Walsingham again.

Grand Master Sven Johansson,

The Rosicrucian Order,
at Greenwood Gate,
Crowborough, East Sussex.

The Rosicrucian Order is a mystical tradition, hidden and secret for many hundreds of years, which has its origins in ancient Egypt. It has been my spiritual home for longer than I can remember. It infuses me daily with the inspiration to go on, always to strive to improve my perception of and attunement with God.

In spite of our great technological advancement, we are still as children when it comes to matters pertaining to our spirituality. Through my lifelong devotion to the ideals of the Rosicrucian Order, I have found a broad tolerance of all religious, mystical and philosophical persuasions. Ultimately, humanity and all the intellectual constructs it has created will bend to the infinitely superior force that makes this universe possible.

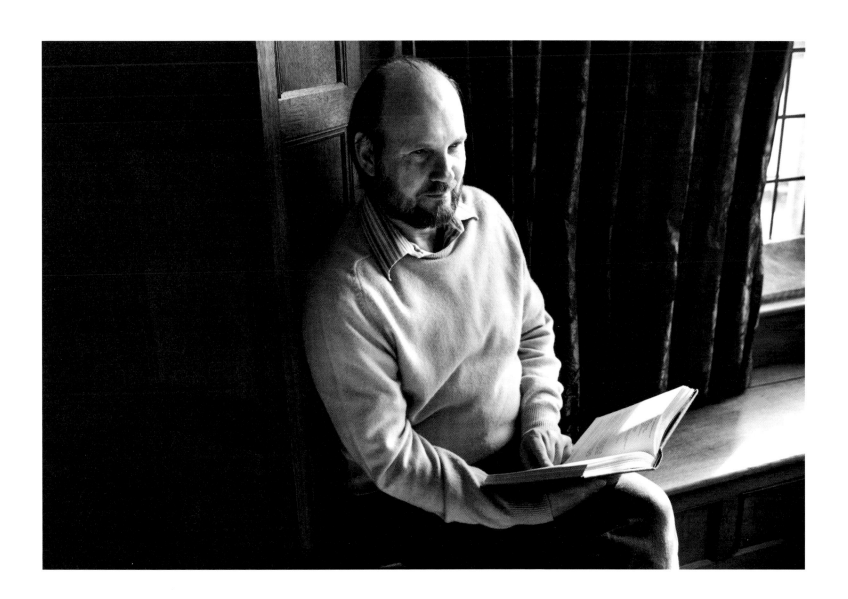

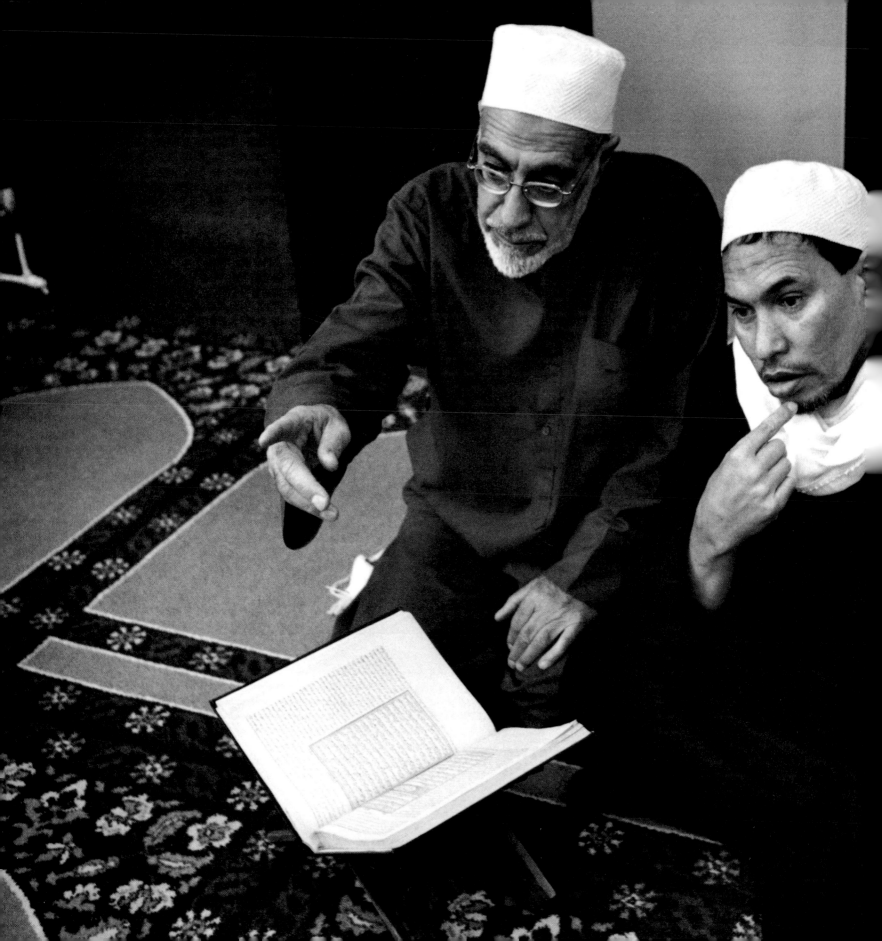

Imam Said Hassan Ismali,

Muslim,
explaining the meaning of the Qur'anic verses,
at the South Wales Islamic Centre,
Cardiff.

I am a British born Yemeni Muslim, the product of a mixed marriage. Recently, I lost my wife of 40 years which caused me great grief and sorrow. However, being a Muslim eased my suffering, because death is an experience that every living creature has to face – as the Holy Qur'an states: 'Every soul shall taste of death... and when their term comes, neither can they delay nor can they advance it one hour.'

Islam has relieved me of the burden of death and has taught me to accept it. Believing in Almighty God and preparing myself to meet Him when my term ends on this earth is at the heart of my faith. Any Muslim who spends his life obeying his Creator and shunning all evil can only relish death.

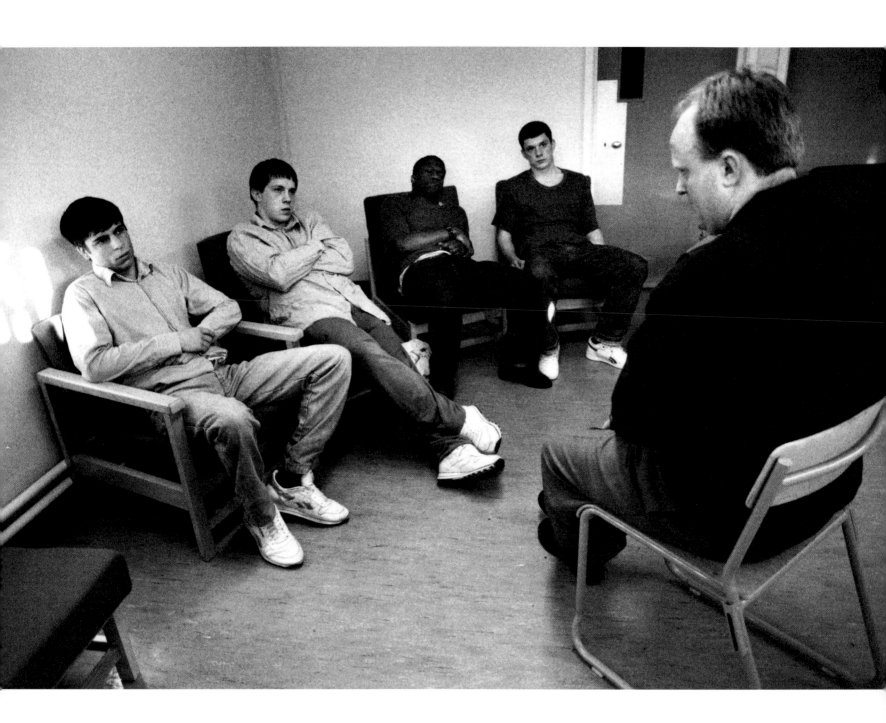

Steve Wills,

of the Brahma Kumaris,
giving a meditation class at Warren
Hill Young Offenders Institution,
Woodbridge, Suffolk.

When I was 13, my parents split up and my mother walked out on the family. Without much love, and having no one to turn to, I searched for the meaning of life. Why can't people get on? Why don't older people have any sense? Why was this world full of hate, greed, destructiveness and doubt?

After trying different avenues of exploration, including religion, philosophy, occult practices, drugs, power tripping, rebelling against society and participating in extreme left-wing militant organizations, I gave in, and accepted this hellish, materialistic, corrupt world as a way of life.

Then I stumbled on the Brahma Kumaris. They taught me that I was a spiritual being, filled with peace, love and happiness. And how to experience God as my parent. And why people, being under the influence of negativity, behave as they do. And the law of *karma* – the cause and effect of action.

I felt that with my life's experience I could bring benefit to people from similar situations. This inspired me to go into prisons and teach positive thinking and meditation classes. Through these teachings, prisoners can deal with their inner feelings, and I know that some of them experience a positive and lasting transformation.

Jill King,

Mormon,
Family Home Evening,
Nuneaton.

No success in life can compensate for failure in the home. Members of the Church of Jesus Christ of Latter Day Saints set aside Monday evenings as Family Home Evenings. We take time to read from our favourite Scriptures, and after reading we have a discussion on how we can apply the principles we have learnt from the Scriptures in our own lives, whether this be school, university or work. We firmly adhere to the view that the value of religious convictions must be demonstrated in the way we live our lives.

I joined the Church at 17, and met my husband who was also a member. I was looking for a religion that was not just a Sunday experience but would be with me every day of my life. The importance of marriage (we believe that once we marry, we remain together for eternity) and the raising of children in a safe and loving environment is central to my religion

What makes me different as a Mormon and makes my religion stand apart from the others is that our Church has as its leader a prophet of God, who receives revelation from Jesus Christ to direct the Church here on earth. We believe that Jesus Christ is the head of our Church and that our prophet, just like Moses in the Old Testament times, is his mouthpiece. This gives me immense strength and assurance in my religion throughout my daily life.

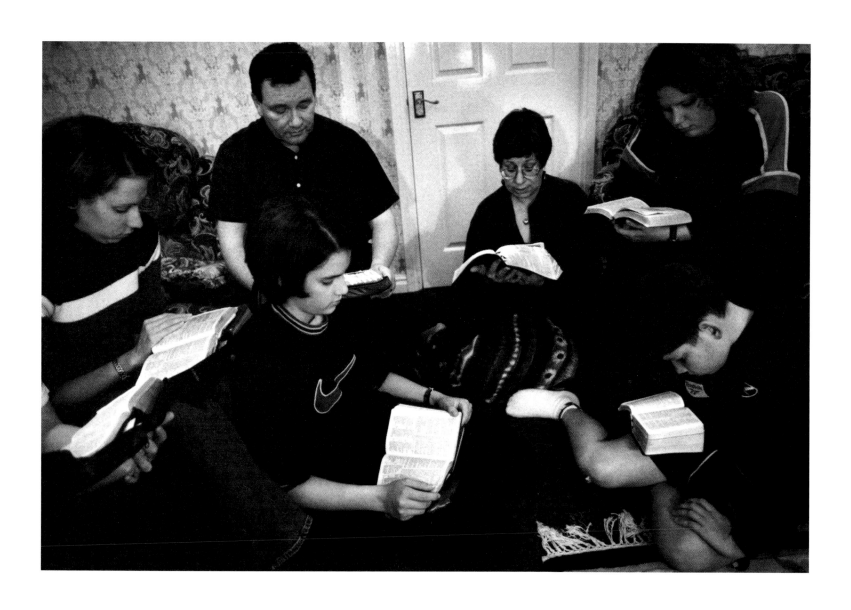

Ajahn Candasiri,

Buddhist (Theravadin),
practising walking meditation
in the woods at Chithurst Monastery,
Chithurst, Sussex.

It's a simple life; we live close to nature with no money and few posses-
sions, which doesn't necessarily mean that our minds are simple –
indeed, that is the work we need to do for ourselves.

I joined the monastery nineteen years ago. The practice of medita-
tion allowed a shift in relationship with the thinking mind, from an
unquestioning assumption that all thought must be correct to a gentle
scepticism.

Often I'm asked, 'But what good do you do for the world?' Before, I
worked as an occupational therapist in a psychiatric hospital. Now,
through learning how to acknowledge and resolve my own difficulties,
I discover something of real value that can be shared with others. The
monastery is an open place; many people visit it or look to it for inspira-
tion and encouragement to live their lives according to values other
than those most commonly presented to them. They see that qualities
such as renunciation and moral integrity bring a deeper and more
enduring sense of happiness than any amount of material success.

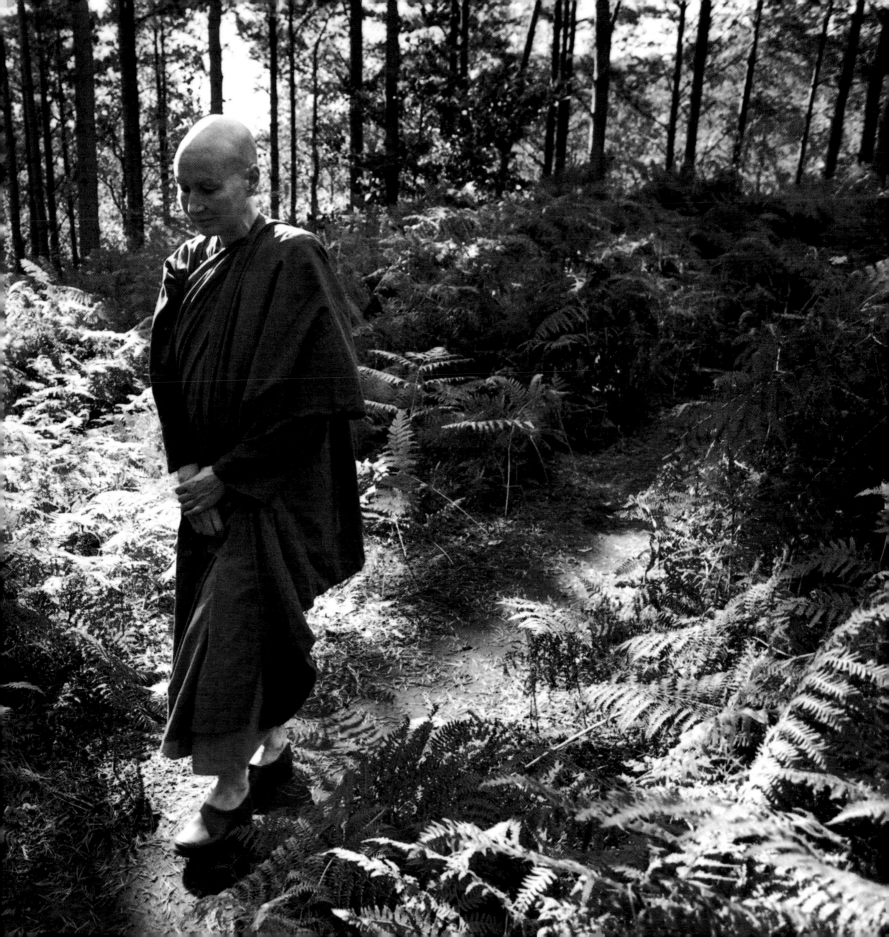

Sukhwinder Sohanpaul,

Sikh,
celebrating Guru Nanak Day,
Chapeltown Road Gurdwara,
Leeds.

Guru Nanak was the first Guru and founder of Sikhism. On his birthday my family and friends take the day off work or school and we celebrate at the Gurdwara – or Sikh temple. We sit in the large prayer hall, called a Diwan. The men sit on one side, and the women on the other. We listen to hymns and prayers from the Sikh holy book, called the Guru Granth Sahib, and we thank God for everything he has given us. After this we are given *Prashad* (holy food), which is semolina pudding – it is given to the whole congregation to show that everyone is equal. Then we go downstairs and eat *Langar* – this is food which is provided every day by the Gurdwara, and is offered to everyone.

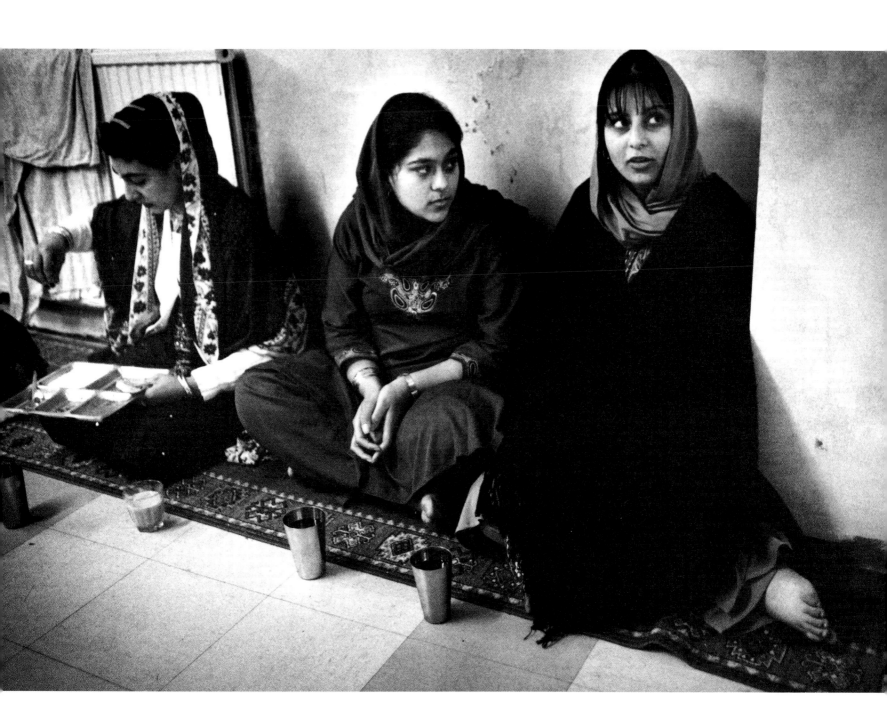

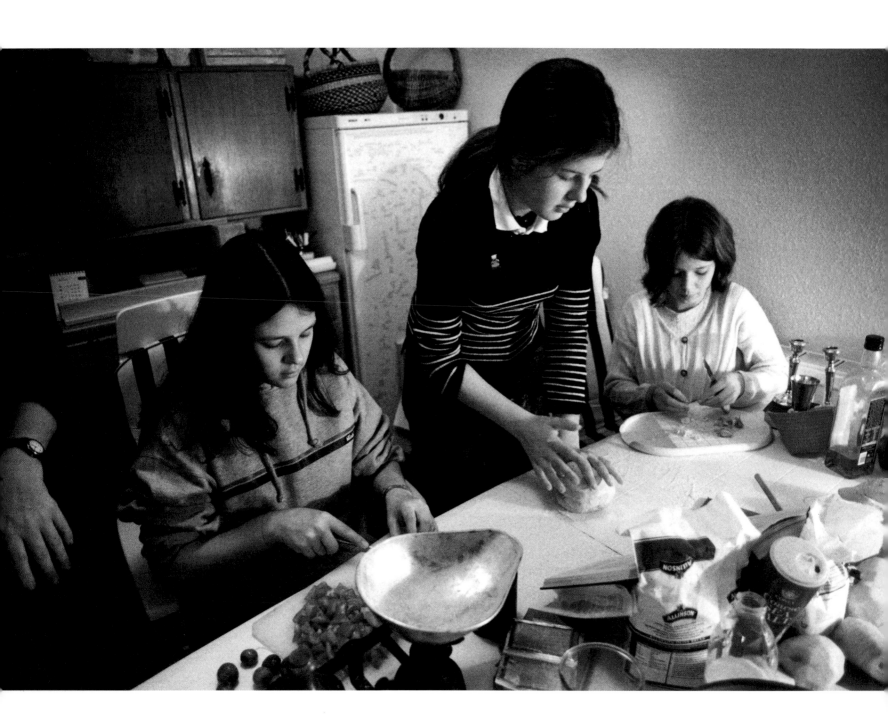

Elisheva Shapiro,

Jewish (Liberal),
preparing challa for the Sabbath,
Birmingham.

The Sabbath, on Friday night, is very special. It is a time when the family can come together in preparing and eating the meal. We make our own challa (the plaited bread), which we eat with the kiddush wine and say some special prayers. During the meal we get the chance to have an undisturbed time, something we might normally miss out on during the hectic week.

It is not very often that we go to synagogue on a Friday, but my sister Jessica and I regularly attend religion school on a Saturday, and my other sister Abigail teaches there. I met many of my good friends through the school. My Jewish identity is very important to me, and I like to feel part of our community.

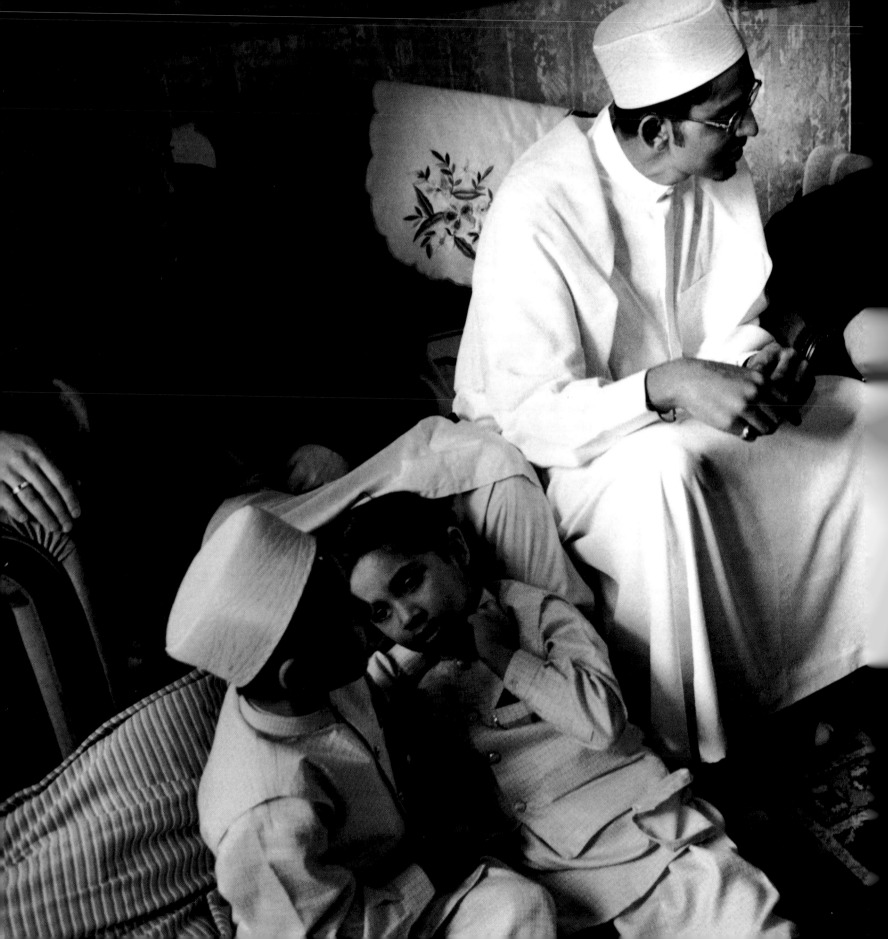

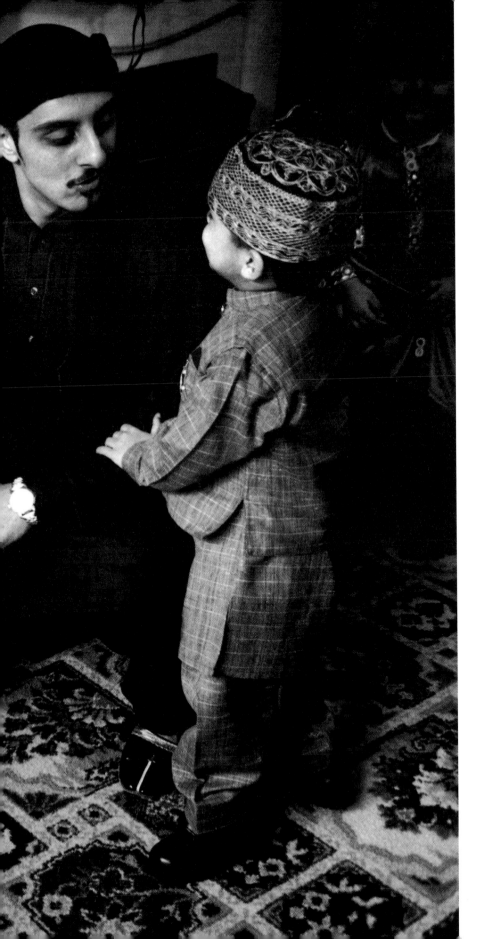

Sohail Bhatti,
Muslim,
celebrating Eid-ul-Fitr with his family,
Bradford.

I am not a religious person, although in this photograph I am wearing the traditional dress of Muslims. You would only see me in this dress on Eid or at a funeral. It's not that I don't like going to mosque, but I don't get the time. But on Eid I have to go to mosque, if I don't the day doesn't feel the same, it's like there's something missing – it gives me peace of mind and a sense of well-being.

Eid is a special day for us all. It is the feast breaking the fast at the end of the month of Ramadan. I go to the mosque with my father and brothers, we pray and afterwards greet friends and relatives. The day is spent with the family at home, and visiting aunts, uncles, grandparents... My mother will cook a large meal for us all, which we sit together and eat. The day is totally devoted to the family, because on a normal day everyone is so busy in their own lives that no one gets the time just to sit and chat.

Bhagwan Singh,

Sikh,
praying at the Havelock Road Gurdwara,
Southall, Middlesex.

A Sikh is directed to concentrate his mind on God, to reflect on God's virtues such as love, benevolence and kindness. He practises this to inculcate such virtues into his own character.

Through constant meditation, a Sikh develops a feeling of affection and love for all humans, who are 'children' of the same father, God. For Sikhs, God does not reside in the seventh of fourteenth sky, or any other place far from the earth. God lives in the hearts of humans. There is no place without Him.

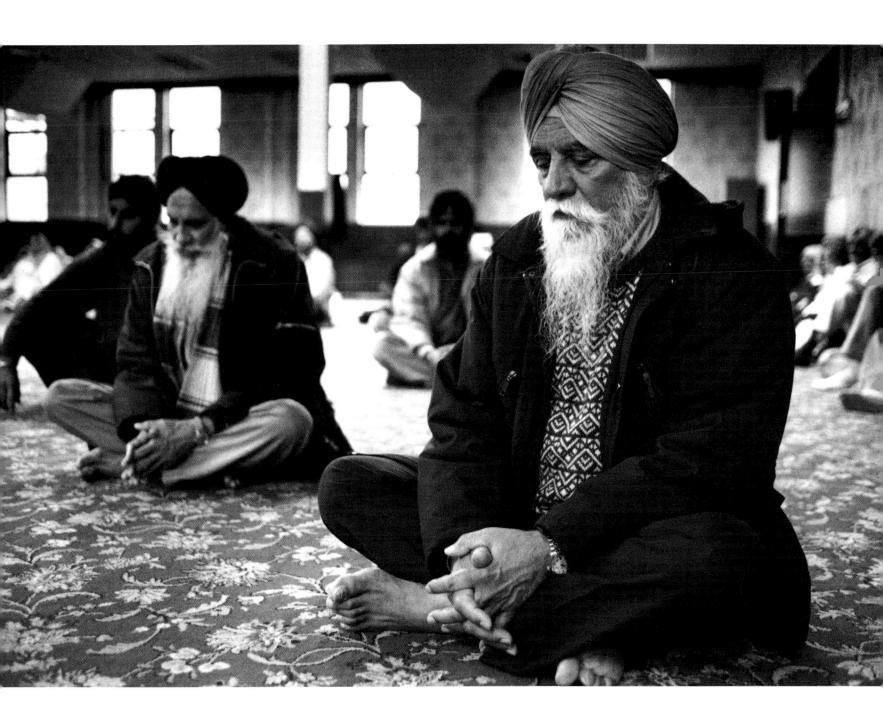

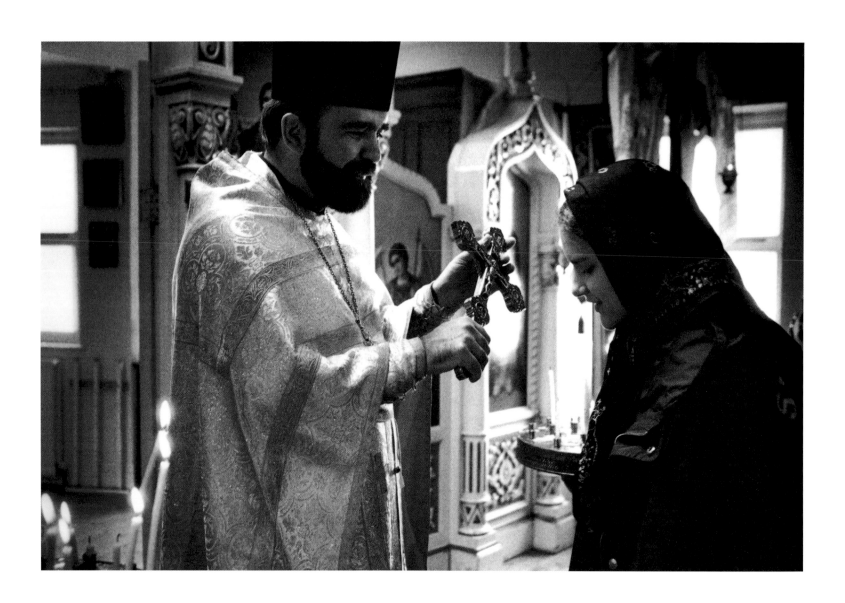

Father Vadim Zakrevsky,

Russian Orthodox Priest,
presenting an icon during the
Christmas service, parish of the Dormition
of the Most Holy Mother
of God, London.

I am a priest of the Russian Orthodox Church Abroad. In autumn 1997 a one-year old child, whom I had just baptized, died in my arms. I, being a doctor with experience of working in ambulances, say this with all responsibility. After 2-3 minutes, the ambulance arrived and took the child to hospital. He started to breathe again, but his body remained unable to move. Prayers were said for little Michael in London, Sydney, Melbourne, San Francisco and New York and in the monasteries in Munich and the Holy Land. I visited him in hospital, and while I was anointing his body with oil (which symbolizes the gift of the Holy Spirit) he started to move his limbs. Now he is alive and well and in his 18 months he has been the most diligent parishioner: he does not leave the church until he kisses every icon. Our Lord heard our prayers.

By such examples, the Lord reminds us of His Presence in our lives every day and every minute. It only depends on us, whether we want to see our God and accept Him.

Alex Lewis,

Jewish (Orthodox),
studying for his Bar Mitzvah,
Manchester.

On average, it takes a Bar Mitzvah boy about a year to learn the portion of the Torah (first five books of the Jewish Bible) that he must read out in the synagogue for his Bar Mitzvah. (The Bar Mitzvah marks the entry of a Jewish boy into the full responsibilities of Judaism). I found it so hard sometimes that I wanted to give up, but urged on by my family and my teacher, Mr Mann, I managed to get through it. Pushing my homework aside to learn was also difficult and time-consuming but it was all worth it.

The Torah is written without vowels, so I had to learn my Bar Mitzvah piece, including the tune, more or less by heart. This was no mean feat as the piece occupied about three full pages of printed Hebrew and took 25 minutes to sing from start to finish.

When I was on the Bimah (centre stage in the synagogue), and the congregation were all looking at their Chumashim (printed version of the Torah), waiting to spot my mistakes, I was very nervous, but after the first few lines, everything flowed back into my head and I said whatever felt right. When it was over, I was relieved but sad that it was finished and I felt like I wanted to do it all over again!

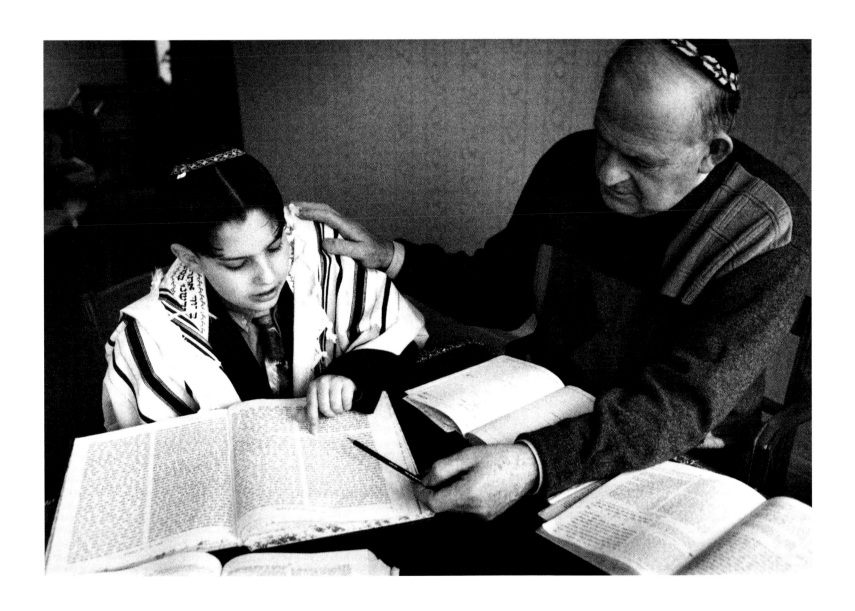

Shashikant Padamshi Mehta,

Jain,
performing temple worship
at the Jain Centre, Leicester.

My faith teaches me that my soul is pure, eternal and always in Bliss, but most of the time I am unable to realize that, following selfish worldly desires, and that is when I suffer. My passion causes attachment to the material world and then I forget who I really am.

Jainism teaches me that the meaning of life is to conquer myself with my own efforts - no priest or external power can do this for me. I worship Thirthankara (the spiritual founders of the Jain path) as examples of Right Faith, Right Knowledge and Right Conduct. When I meditate on these qualities, at the temple or at home, I remember how to be a good husband, a good father and a good member of society.

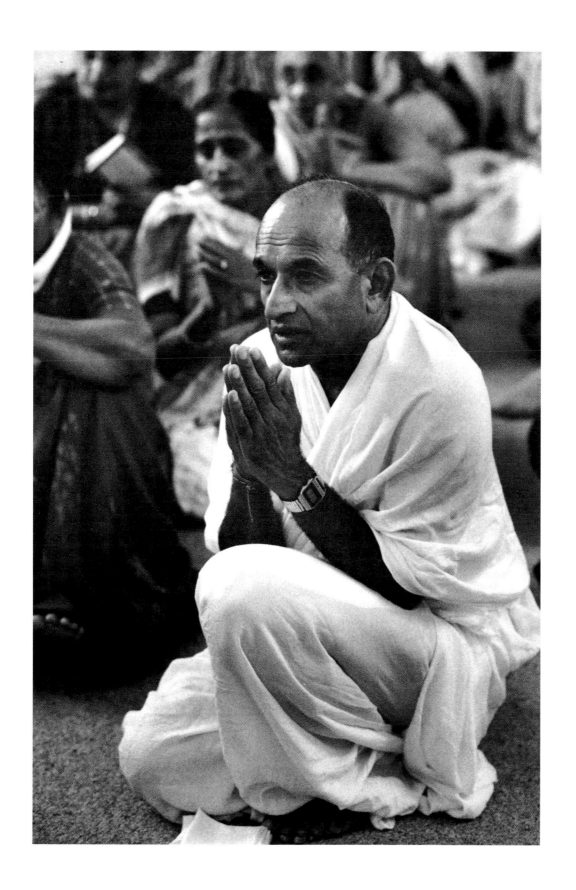

David Lawson,

spiritual teacher and healer (non-affiliated),
performing a healing,
London.

This is a photograph of me giving a healing to my partner, Justin Carson, taken only a few weeks before he died. For eleven and a half years, Justin and I lived together and worked together as spiritual healers and teachers of self-healing techniques.

Justin was an extraordinary example of the work we did together. For seven years, he lived through many illnesses that would have killed anyone else. These conditions included a cancerous growth behind his palate and a toxo-plasmosis lesion on his brain. Justin extended and enhanced his life through a combination of carefully chosen medical treatments, acupuncture, positive thought techniques, herbal medicines, flower essences, spiritual healing, a love of life and a belief in spirit. He also thrived on a strong dose of love from me and some sheer bloody-mindedness from us both.

Justin lived life fully, with dignity and humour, right up to the moment he died. He and I shared an interest in the truthful core that resides within most spiritual paths. We both held a belief that this period in history is special. This is a time when many people are growing beyond the rigid dictates of religion to honour the beliefs of others and to listen to their own spiritual truths from within. Since his death, Justin has spoken to me from spirit, confirming my belief that life continues and that death is just an illusion.

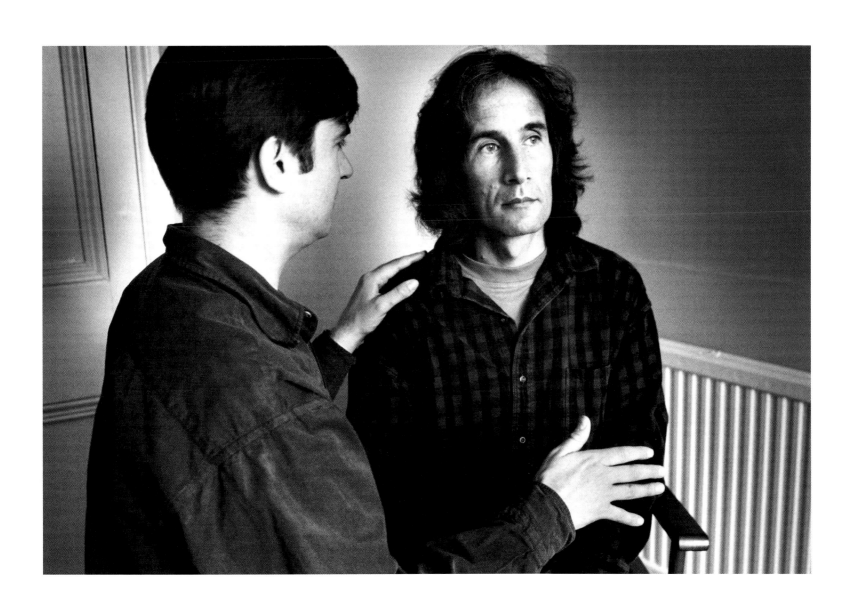

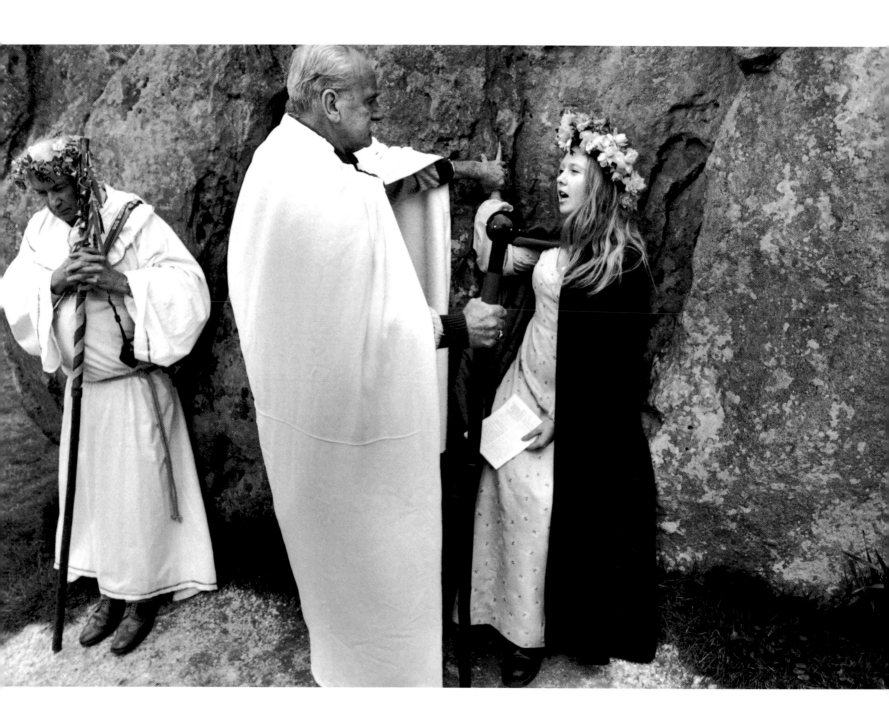

Liz Coleman,

Order of Bards,
Ovates and Druids,
as the Spring Maiden at the ritual
of the Spring Equinox,
Avebury, Wiltshire.

The Spring Equinox is a time of great rejoicing because it signifies rebirth from the cold and dead of winter. The Spring Maiden is a representative of all that is new and beautiful and I was very honoured to be chosen. In this ceremony, I am being joined to the stones and the land and vowing to protect them. Avebury has always been a focal site for those who have spiritual inclinations, and those who are interested in our cultural heritage. Not only is it physically impressive, but it has a definite presence which leaves you feeling very small but enriched.

I was introduced to Druidry from an early age by my mother, who is still very involved with the organization, and was one of the earliest people to reach the Druid grade. I have always felt an affinity with the land and an older way of worshipping the beings at work in it, and this has strongly influenced my life. I am hoping to read Celtic Studies at university, and to deepen my knowledge of our ancestral heritage.

Peter Chin Kean Choy,

Taoist, practising T'ai-Chi,
at the Rainbow T'ai-Chi Chi Kung Centre,
Ashburton, Devon.

What is the point of having a spiritual heart if you don't have a relationship with your physical heart? In Taoism, we *embody* the spiritual commitment.

We study the balance of the opposite forces in Nature, which we call Yin and Yang, and which we see in all aspects – shadow and light, masculine and feminine, negative and positive, hard and soft... T'ai-Chi means 'the river of energy which unites Yin and Yang and flows into the sea of energy'.

In our daily life we need to consult with our body – our internal organs need our conscious awareness. Taoists believe that spirits reside in the organs, and they have access to cosmic energy. After many years of diligent practice, you will feel your body deliciously supported by the air around you. Every moment in every movement is a tingling and joyous T'ai Chi dance.

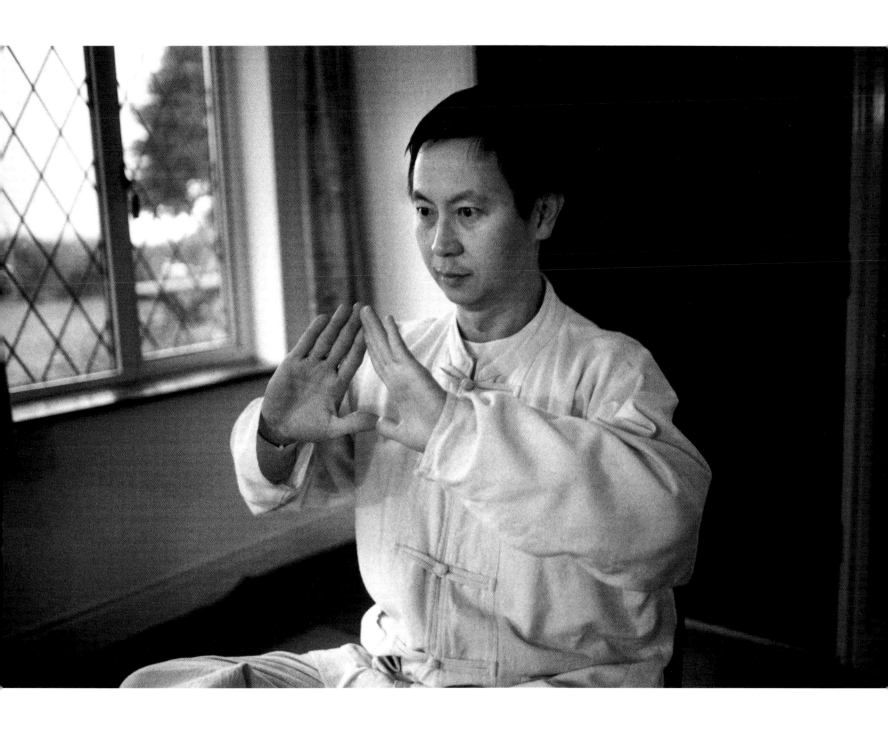

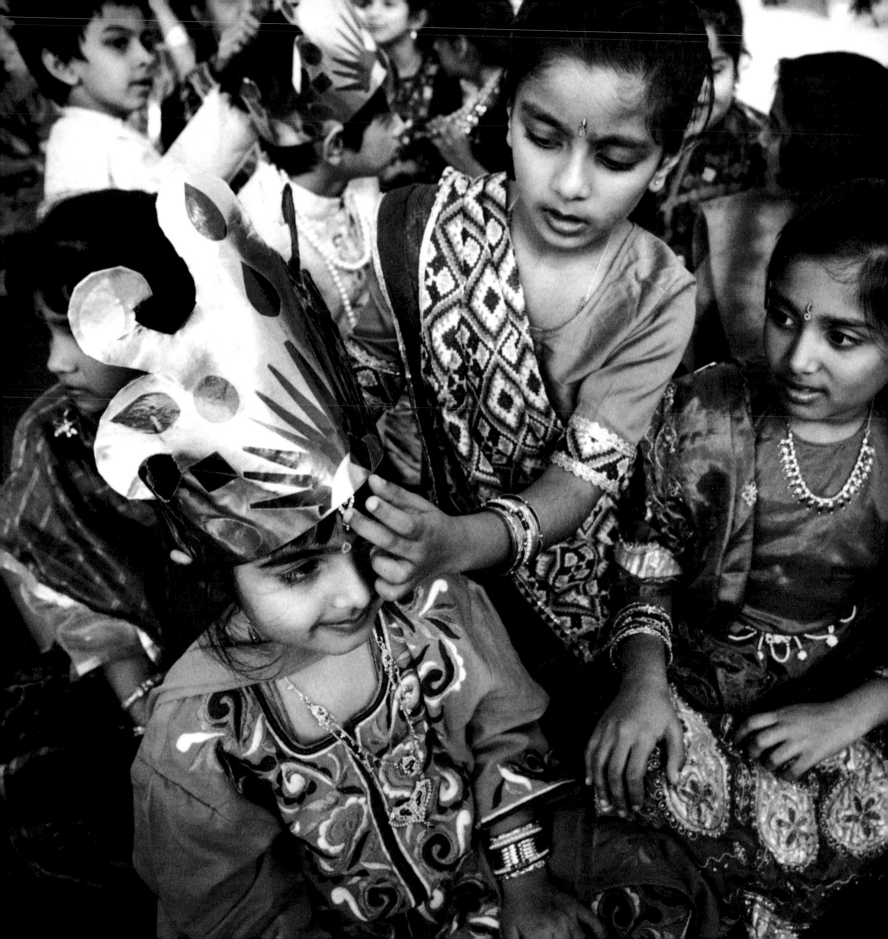

Jessica Patel,

Hindu,
Diwali School Play,
Swaminaryan School,
London.

I am a British Hindu. In Britain, we celebrate Diwali, the Festival of Lights. We all wear new Indian clothes and go to the homes of our relatives to give each other gifts, and we light fireworks.

We celebrate Diwali because this is when Lord Ram, Lakshman and Sita came back from the forest. Lord Ram was an incarnation of God, and he went into the forest and killed the demon.

Diwali is about sharing and being with your family. It is also about being kind, happy and enjoying yourself.

Dharmacharini Srisambhava,

Western Buddhist Order,
meditating in the Shrine Room,
London Buddhist Centre.

I am not a Buddhist nun, yet Buddhist spiritual practice sits at the centre of my life. All aspects of life unfold from that central point. Buddhism informs how I spend my time, how I act, speak and think.

Practising as a Buddhist has enabled me to become a much happier, healthier human being; that, however, is just its starting point! Through meditation and the practice of Buddhist ethics in my daily life, I am constantly working to develop my awareness, and ever more creative, expansive mental states. Ultimately, I am looking to realize in the very depths of my being the inter-connectedness of all life; to allow my experience to be ever more deeply permeated with compassion for all life – a compassion which is imbued with the wisdom of true knowledge and understanding.

The Western Buddhist Order provides a positive context within which I can live my life out here in the world as a Buddhist alongside others also committed to realizing their potential as human and spiritual beings.

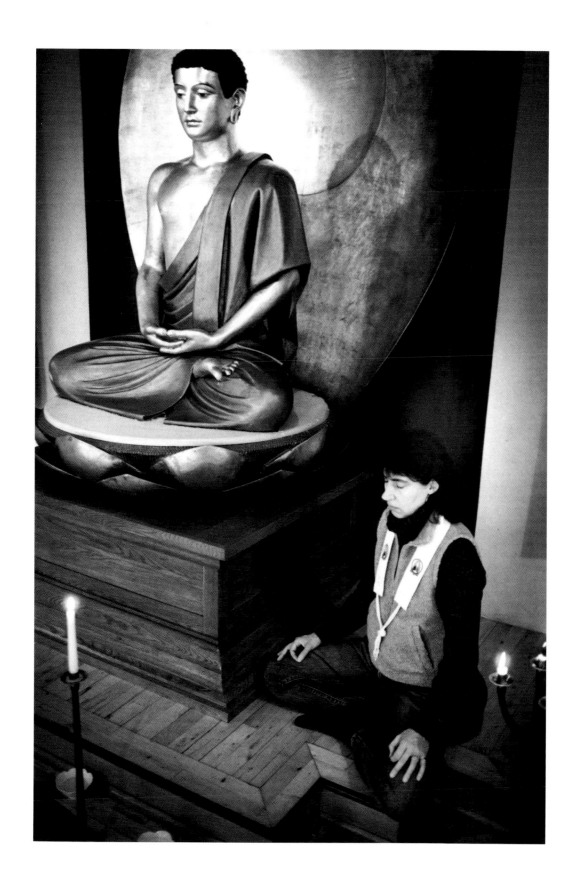

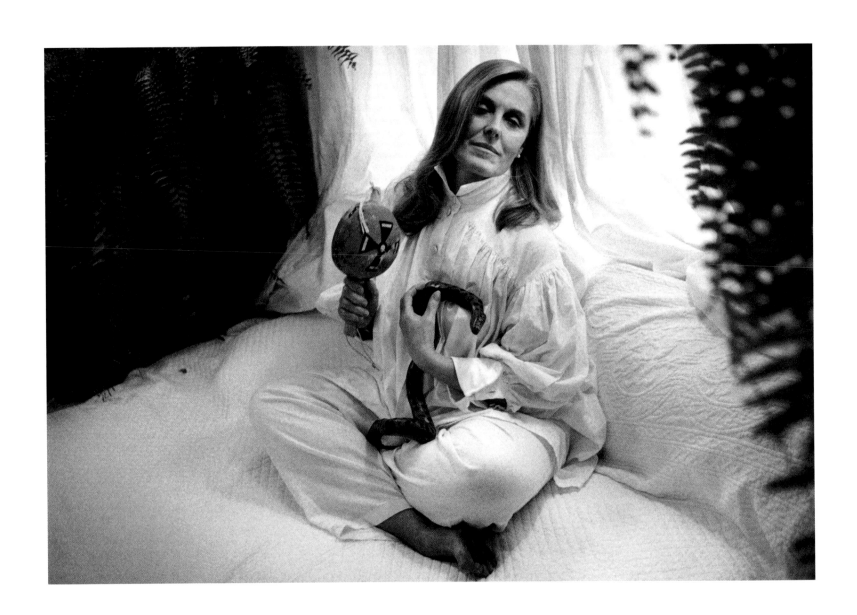

Leslie Kenton,

Shaman,
Rattling in the Spirits,
Manorbier,
Pembrokeshire, Wales.

Shamanism is not a religion, it's the oldest method in the world for expanding consciousness – shifting from ordinary reality into the numinous quantum realms. The word shaman means 'see-er' – one who sees simultaneously both the material aspect of form, and the invisible aspect of consciousness. Its techniques have been practised by men and women for at least 30,000 years.

As a shamanic practitioner, I am able to move into non-ordinary reality at will. Often I use the sound of the drum or the rattle, or I enter 'sacred silence'. I work with animal spirits, gods and goddesses – what we would call teachers or guardians. When I'm doing healing, the spirits do the work. I focus my intention with compassion for the person I'm healing, and ask the spirits to do what is necessary, for their wisdom is far greater than mine.

I came to shamanism while I was writing a book for women about the menopause. I was aware that many people in mid-life come to find that they have climbed to the top of the ladder, only to realize that the ladder was against the wrong wall – that they have lost their soul. I discovered that shamanism offers simple techniques for recovering that lost soul. It requires no guru, no priest, no religious hierarchy to intervene on our behalf. Each one of us can learn to live out the highest level of our creativity, our inherent joy and our own divinity. Spirit is in everything – when we realize that, life becomes quite remarkable.

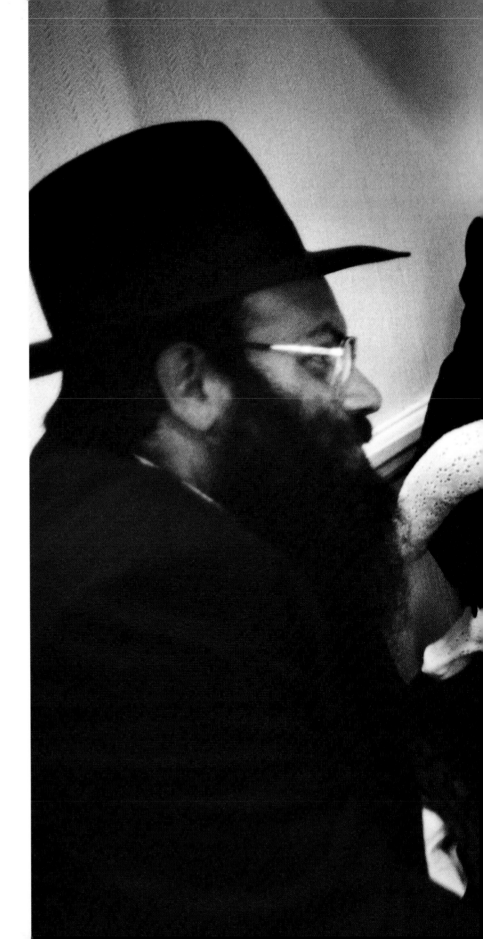

Rabbi Golomb,
Jewish (Hasidic),
with his baby at a family gathering,
London.

Tradition is a key element in continuing the unbroken chain from Sinai, and for that one needs children. If one's religion is an added extra to an otherwise secular way of life, then it takes special effort to transmit that tradition to the next generation. For observant Jews, the process is much easier. Real Judaism is not a religion, it is a way of life that one eats, drinks, sleeps and breathes all and every day. Children are part of their heritage the moment they are born.

A father plays a major role in the religious practices of the home and these include looking after the children – after all – it's part of tradition. So when engrossed in discussion of the Talmud (biblical commentaries), or just plain chit-chat, it's perfectly natural to be left 'holding the baby'.

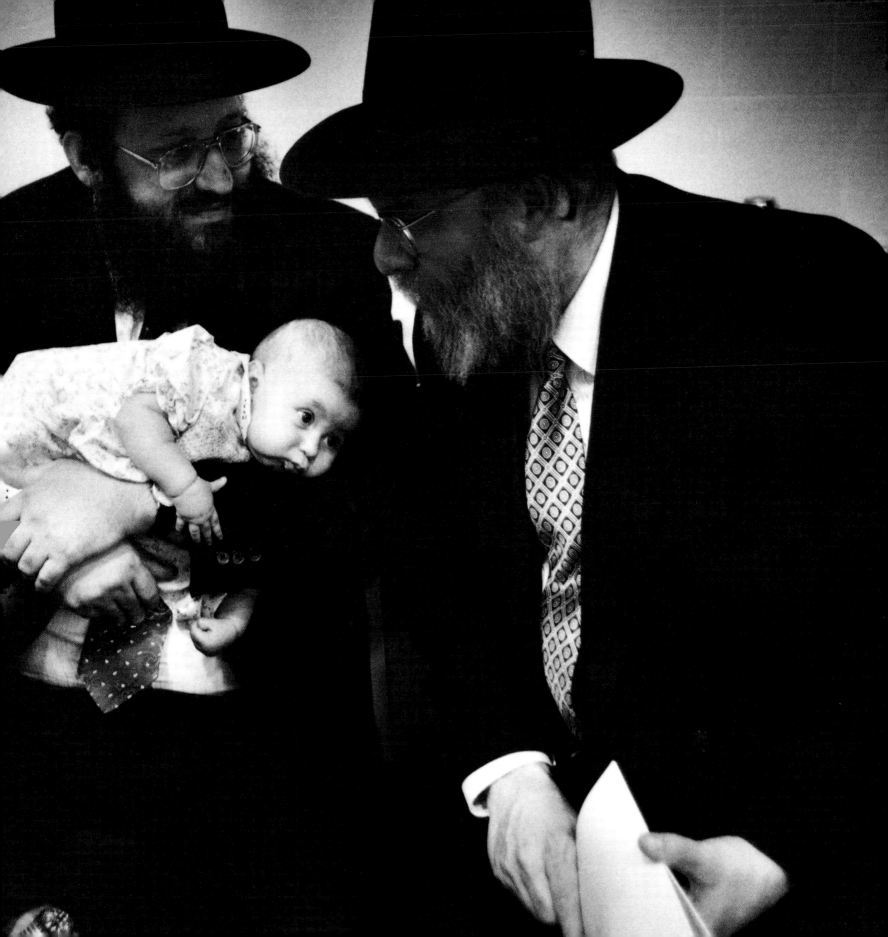

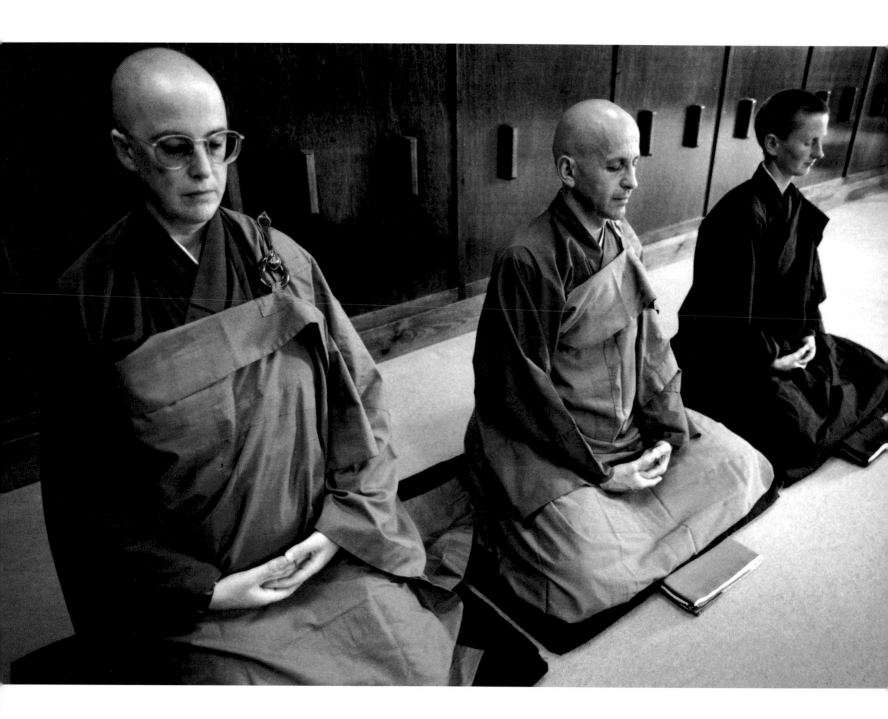

Rev. Fuden Nessi,

Buddhist monk (Zen),
in meditation at Throssel Hole Monastery,
Carrshield, Northumberland.

One of the most important aspects of being a monk is to renounce self-centredness. This is an on-going process rather than a one-time event, and it is obviously not something that is restricted to monks only. (We use the word monk for both male and female monastics in our order.) At the root of renunciation is the wish to cease from evil, do only good, and do good for others.

The heart of our practice is meditation, where we learn to be still and let go of everything. Through the practice of meditation and living our life in accord with the Buddhist Precepts we open ourselves to our enlightened nature, which we call Buddha-Nature, and to the compassion, love and wisdom inherent in us. The training of a monk consists of learning to put this into practice throughout his or her daily life. I chose to become a monk because this is the right path for me, but true spirituality depends on the sincerity and application of a particular person not on whether or not they are a monk.

Ervad Rustam Bhedwar,

Zoroastrian priest,
at the Fire Temple,
London.

When I was seven years old, and living in India, my father sent me to a boarding school for the priestly class. I was there for six years, and passed through the two initiation ceremonies for Zoroastrian priests, in which I had to stay in the Fire Temple for thirty days, meditating and praying. I was miserable at school. Being just a boy, I found it very hard work, especially getting up every day at 4.30 a.m.

When I came to England, in 1966, there was a shortage of Zoroastrian priests, so I became a priest here at the Fire Temple in Kilburn. The Fire is Ahura Mazda's (God's) major creation, and we pray using the fire as a symbol, just like Christians use the cross. I get great pleasure from performing the rituals, and helping the members of my community, doing Ahura Mazda's work.

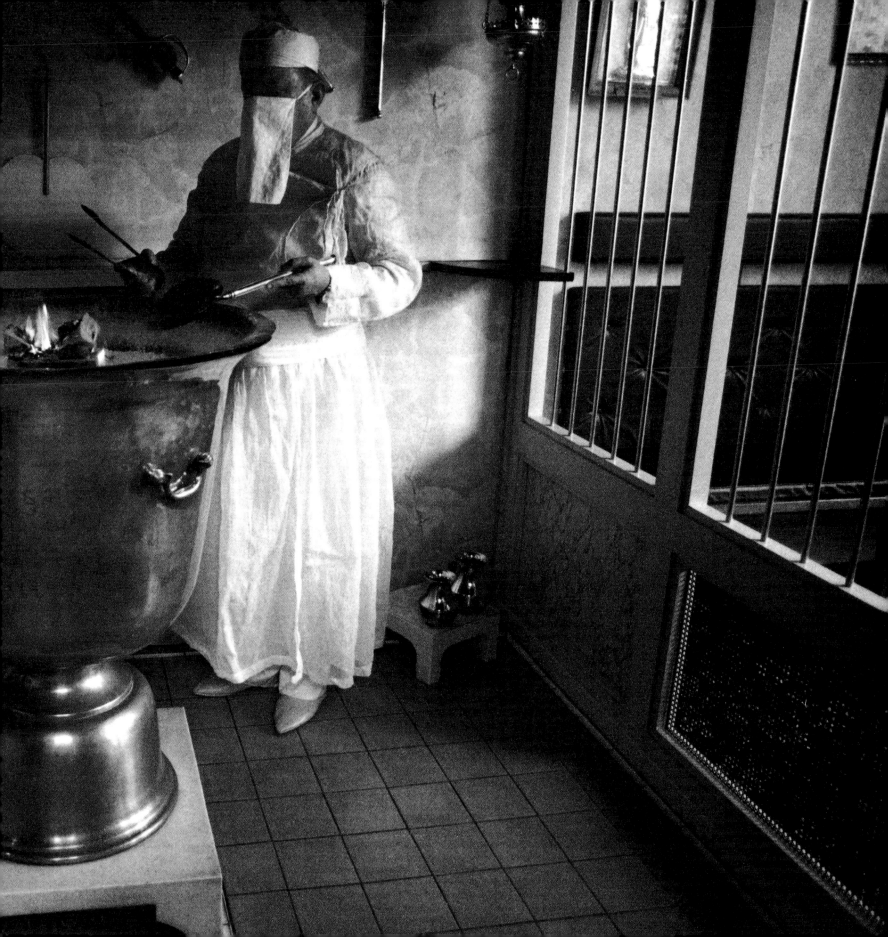

Mr Narandas Adatia,

Hindu,
at his household shrine,
Leicester.

When I was nine years old, my mother died in childbirth. A few hours later our baby brother died also. Our lives were turned upside down in a matter of minutes. My father was in a state of shock and overnight my childhood was lost and I had to grow up. I learned to cook, clean, look after my younger siblings and help run our small shop.

Our life was very hard. My father sought comfort in religion, and he handed that on to me. He taught me to surrender myself to Divinity. I learnt to accept that what happened to me in my life, good and bad, was the will of God - this was what God wished for me.

This belief, which is very important in the Hindu religion, has guided me through my life's struggles, particularly the death of my beloved wife two years ago. The more distressing the trauma, the more I would turn to God and seek his direction. Through prayer and meditation I have learnt to find great strength and inner peace.

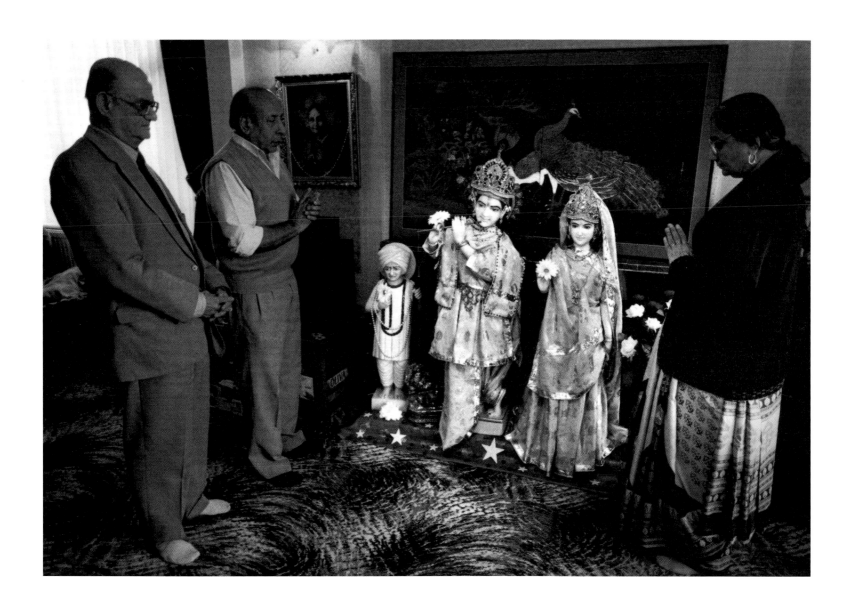

Rev. Roly Bain,

Anglican,
giving Communion as a Holy Fool,
St Mary the Virgin, Bristol.

When I was ordained priest in Southwark Cathedral in 1979, it was one of the greatest moments of my life. That evening I presided over 'the Holy Mysteries' (the eucharist) for the very first time and I felt so privileged to be entrusted with that task and calling. I started clowning a couple of years later and have always seen my clowning and ministry, in whichever garb I happen to be wearing, to be the same. It is extraordinarily foolish to be either priest or clown, let alone both! Yet both priest and clown are the jesters – the only ones allowed to speak of the truth and get away with it; and vulnerable lovers, pitched into the world to do what they can within the dictates of love, compassion and playfulness.

Since 1991 I've been clowning full-time all over the world in hundreds of churches and other places. And it is still the most precious moment when I am asked to preside at the Holy Mysteries once more, not just because others can perceive the priestliness of clowns; not just because it is fitting that a clown presides at this absurd feast of fools where we honestly believe that bread and wine become Christ's body and blood and embrace both its ridiculousness and its truth; but also because it remains precious to me. It's still what God wants me to be and do.

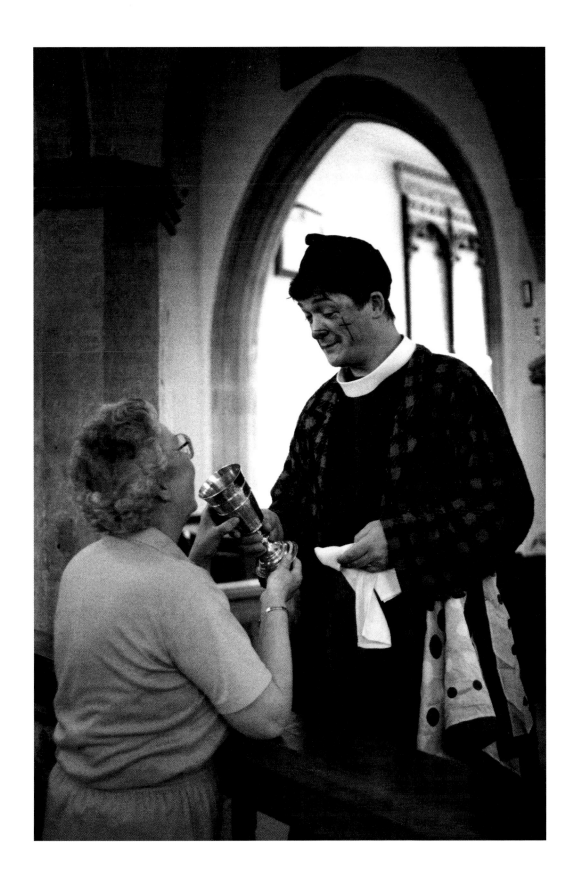

Fred Pilkington,

Jehovah's Witness,
at the International Convention for Jehovah's Witnesses,
Twickenham, Surrey.

Assemblies are times for meeting old friends, comparing experiences, and making new friends of the 44,500 Witnesses who were there at Twickenham this summer. My wife Doris and I have been Jehovah's Witnesses for 41 years, since our baptism by total water immersion in June 1957.

Jesus said, 'Know the truth and the truth shall set you free.' That is why we have preached from door to door for 41 years, to show interested ones what the Bible says. The joy we get starts when we see the look of enlightenment on peoples' faces when a Scriptural truth is seen clearly and in context. It deepens as we observe their progress to worship Jehovah (we believe that Jehovah is God's proper name).

We grieve when we see the atrocities and the chaotic state of the world, but Scriptures prove that God will bring an end to it all at His war of justice, Armageddon. Only then will the earth return to Paradise and the meek and righteous ones will live upon it in peace.

John Menz,

Darvell Bruderhof (Christian Community), doing 'clean-up' after a communal meal, Robertsbridge, East Sussex.

Our love for one another is not extraordinary. But we do need to love without getting tired. We practise this in the small things of daily life – like washing dishes: small words of kindness, a thought for others, our way of being quiet, of looking, of speaking and of acting. These add up to faithfulness.

Efforts to organize community artificially can only result in ugly, lifeless caricatures. It is only when we are empty and open to the Living One, to the Spirit, that he can bring about the same life among us as he did among the early Christians. The Spirit brings us joy in living and working for one another, for it is the spirit of creativity and love.

Sister Pauline,

Anglican nun,
on a home visit,
Nottingham.

I have always found it difficult to confront physical illness and pain in another; I am uncomfortable, feeling guilty that another is suffering while I am all right. Although I have learned to cope, I still find myself unwilling to 'stay with' another person's pain - and as I sit with them there can be a false cheerfulness covering my anxiety.

Mysteriously, it is the welcoming generosity of the person I'm trying to sit with which spans the divide and mediates God to me in a kind of homely communion of real presence. This helps me to dare to perceive not only God but myself in this 'other' person, and to recognize that this is, beyond all belief, *Holy* communion.

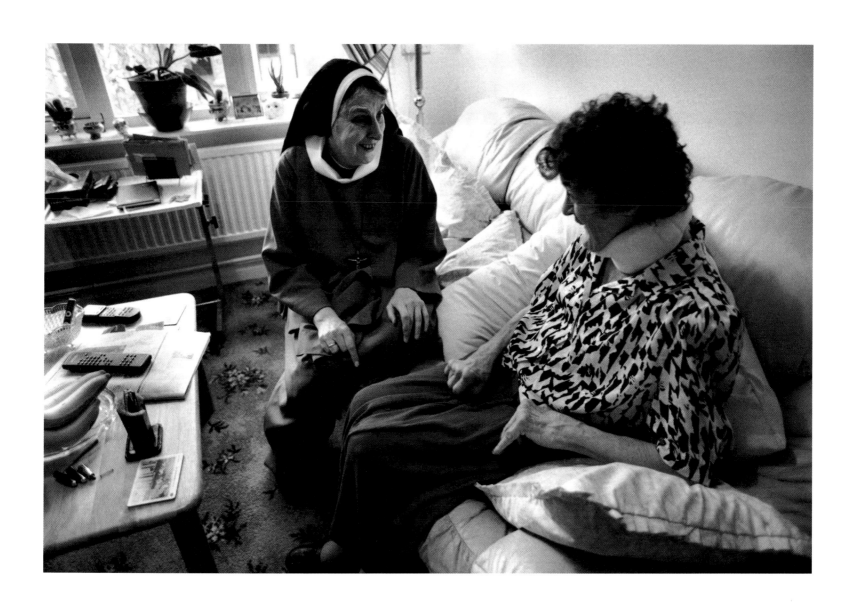

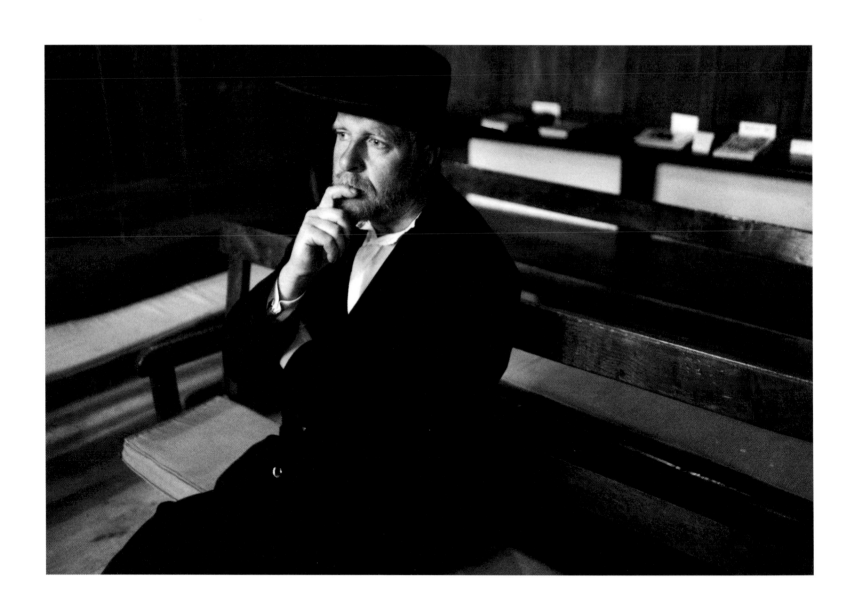

Melvin Roberts,

Quaker,
in Brigflatts Meeting House,
Cumbria.

Quaker worship is based on silence, where we wait experimentally for a communion with each other and the all-enveloping Spirit of love we call God. When the idyllic experience happens, and that may not necessarily be in 'meeting' but out in nature, we are at one with every living thing.

In simple and sincere worship, without rite, clergy, pulpit, stained glass windows, font, symbols or music, we allow our own possibilities to be recognized. I see in the figure of Jesus a mirrored image of my own potential as a human being with something of God deep within me.

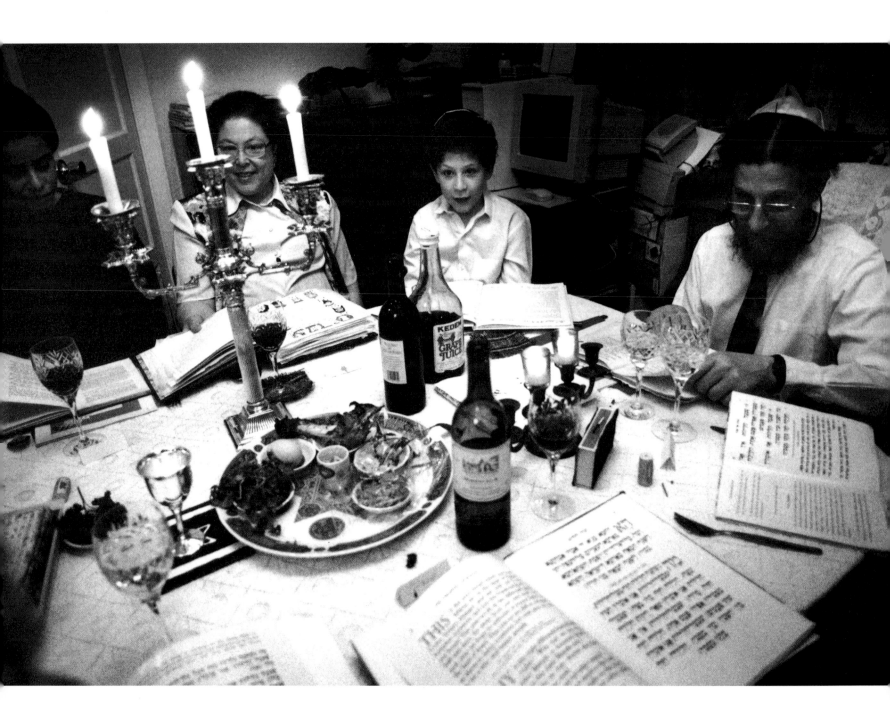

Rabbi Jacqueline Tabick,

Jewish (Reform),
at her Passover supper,
London.

For me, Pesach (Passover) epitomizes all that is best about Judaism, involving, as it does, family, community, the body, mind and soul, ethics and, of course, the God that made all this possible.

You sit at the Seder table (Passover meal) with family and friends. All is clean. The candles shine. The silverware glitters. There is a tempting aroma of food from the kitchen. Who would guess there has been a veritable orgy of cleaning conducted over the past few weeks, or the total chaos of the previous day when all the ordinary crockery and kitchen utensils were carted outside to the garage and the beautiful Pesach utensils brought in and lovingly placed in the cupboards?

The text of the Haggadah (narration of the story of the Exodus read at Passover) challenges us with the eternal questions that affect our very being. Who is free? And what is freedom? And how do we free ourselves from the modern 'Egyptians' that enslave us? And we have to acknowledge that sometimes it is a slavery that we impose upon ourselves. And if God freed us from that ancient slavery, what responsibility does that place upon us to the strangers in our society? The asylum seekers. The refugees. The homeless. And how can we ever repay God for the kindness that God has poured out upon us from that day in Egypt until now?

Victoria McMahon,

Catholic,
making her First Communion, Church
of St. Francis Xavier, Liverpool.

I liked my Holy Communion very much. I was very nervous about making it, and I had butterflies in my tummy. Father Laine and Brother Billy both made me feel happy and safe. I felt that something special happened, and I liked saying the prayers on the altar. My sister Andrea also made her first Holy Communion, and my nephew Jack made his Christening, so it was a great day for all our family. We had a party after with all my family and friends. I got Rosary beads and a prayer book and lots of other presents and some money.

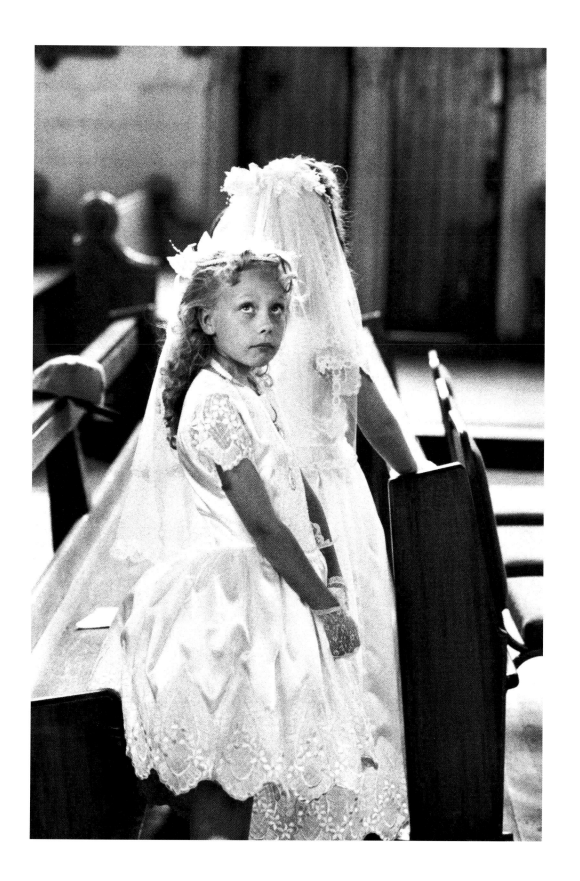

Rev. Clifford Reed,

Unitarian,
Lighting the chalice,
Ipswich Unitarian Meeting House,
Suffolk.

Unitarian worship often begins with the lighting of the chalice, which is the symbol of the Unitarian faith. The communion chalice represents the liberal religious community, open to all who come in good will. The flame represents the loving spirit of truth and liberty to which that community dedicates itself.

I have been a Unitarian for most of my life. During that time, my beliefs have waxed, waned and changed as everyone's should. And yet, throughout, I have remained at home in the Unitarian faith-community. Why? Because whatever changes my faith has undergone, whatever new directions it has taken, whatever new influences and insights have come to bear upon it, the Unitarian community has accepted me. It is a place where I can explore and develop in freedom, a community of loving acceptance which is not conditional on theological 'orthodoxy'.

As a Unitarian minister, my role is to foster this same free-spirited, intelligent, diverse yet spiritually united community which has done so much to mould and enrich my life. I have found it to be a place of simple, compassionate humanity, and of noble, empowering vision.

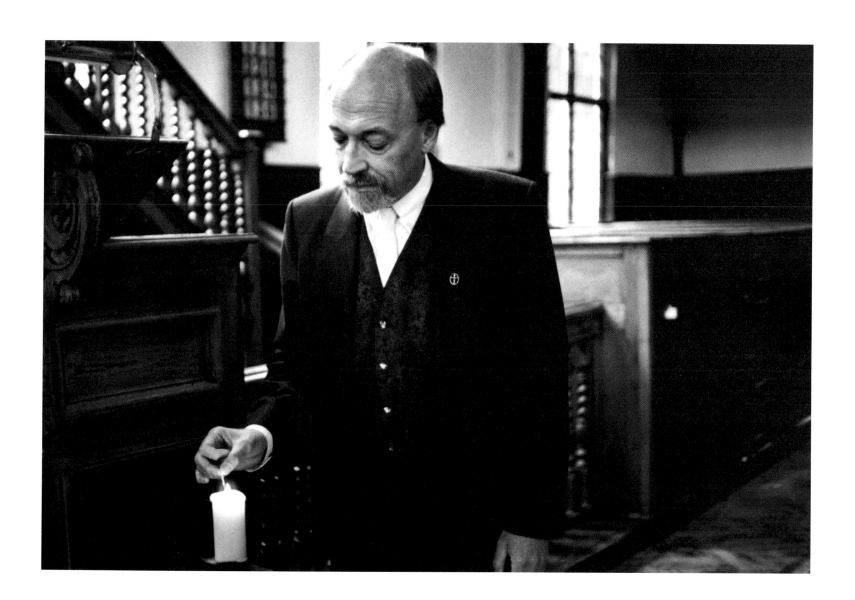

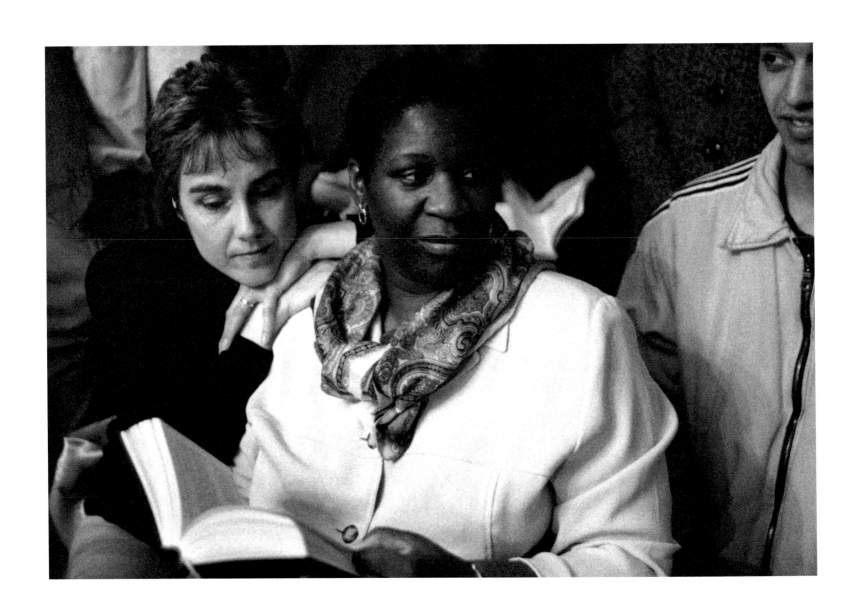

Carmen Henry,

Baha'i,
at a Fireside Gathering,
London.

It all began just over ten years ago. I was working as an interfaith officer in my hometown of Wellingborough. I had been feeling quite depressed about the state of affairs in the world. I saw myself as a social activist, yet felt powerless and wondered what could be done to dispel the grief and sadness I was witnessing.

I found myself seated next to a kindly gentleman, a Baha'i, whom I knew to be relatively sane and trustworthy. This man invited me to investigate the teachings of Bahaullah, the founder of the Baha'i faith. I was extremely moved by them and several months later, on 10 December 1988, I declared myself a member of the Baha'i faith.

As a member of the human race, I desire to know and love my Creator – becoming a Baha'i has enabled me to do that. And the faith's teachings about justice, unity and love affect me immeasurably. They inspire me and confirm that I have a level playing field to make my contributions towards the transformation of a society crying out for spiritual solutions.

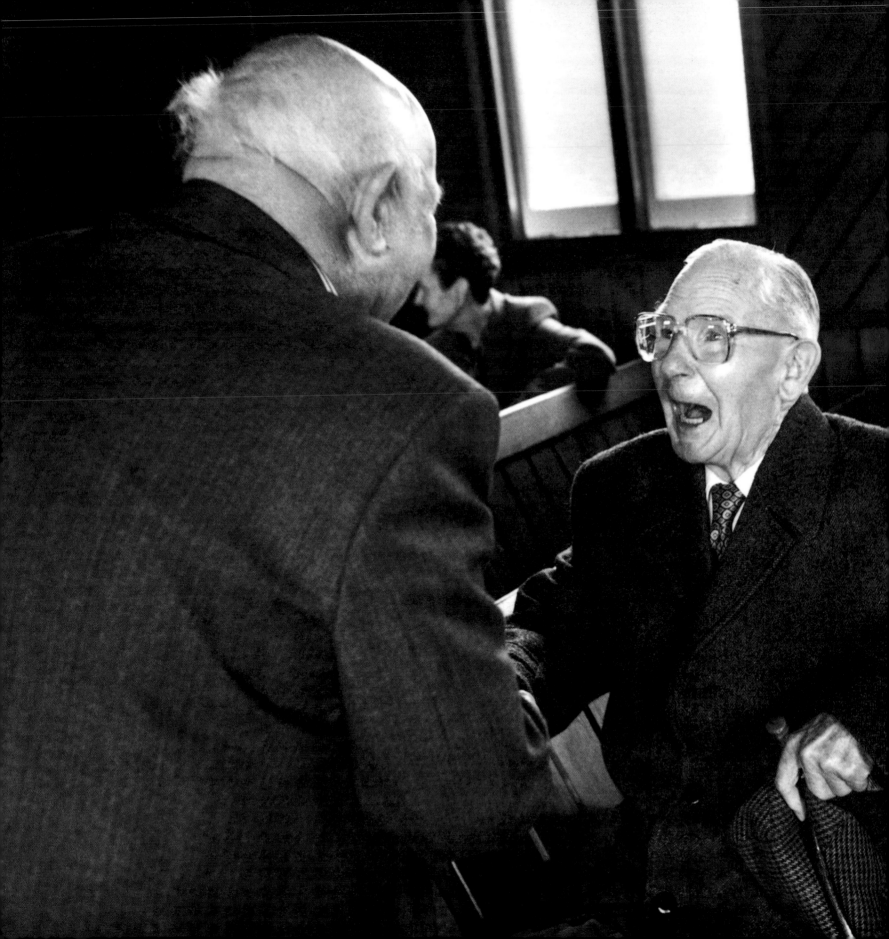

Rev. Eifion Thomas,

United Reformed Church,
at Tredomen Chapel,
Tredomen,
Powys, Wales.

I have been a minister in the Brecon area for the past 60 years and this year I was very pleased to celebrate, along with the faithful members of all my churches, the 60th anniversary of my ordination into the ministry. It was a great occasion.

Throughout my ministry I have had a meaningful and fulfilling life, sharing the experiences of many wonderful people. Being a Church member meant being a member of the community – organizing Nativity plays, friendly but competitive Eisteddfodau, whist drives and many other activities.

The warmth of kinship enhanced the spirituality of true fellowship, strengthened our faith and was a source of great comfort and joy throughout life in all its many facets.

Christianity

At the centre of the Christian faith lies the event of Jesus, believed by Christians to be the son of God. The vast majority of Christians are Trinitarian. This means, in a way that can never be fully understood, God is three persons – usually referred to as God the Father and Creator, God the Son, Jesus Christ, and God the Holy Spirit, the power of God experienced in people's lives. They are inseparable and indivisible. There are not three gods but one God being manifested in three ways. Christians find this way of describing God helps them to refer to the wide range of their experience.

As a result of this mysterious but powerful view, Christians believe Jesus of Nazareth was both fully human and fully divine. The reason for the Son of God's becoming a human being was to give people a way to reach God. Christians believe sin separates them from God and the real relationship between God and humans is blurred by human fault. Jesus's death and resurrection gave people hope that this real relationship could be healed, and it was by God's love and grace that God and his creation could be brought together. This is called the Atonement ('at-one-ment').

At the end of his earthly life, the Holy Spirit came upon all those who accept Jesus's authority as the Son of God. Today, the power of the Holy Spirit is believed by Christians to be active in their lives and they pray to God that the Spirit will guide them in order that they may know God's will and carry it out.

Jesus was a Jew, and his first followers would largely have been Jewish too, but belief in Jesus as the Son of God spread rapidly. Soon the followers of Christ, the Christians, were largely Gentile (non-Jewish), and Christianity moved out of the area of Palestine and across the world. The Church continued to grow, but differences of doctrine meant that in 1054 C.E. the Orthodox Church, which was largely in the eastern Mediterranean area, separated from the Catholic Church of Rome.

In the 15th and 16th centuries, increased discomfort with the Church of Rome encouraged groups to emerge whom we now call 'Protestants' because they arose out of 'protest'. Unlike within the Catholic or the Orthodox Church, Protestantism has no central organization or focus. The Anglican Church regards itself as a bridge between the Roman Catholic Church and Protestantism.

In the centuries following the Reformation, the number of Protestant denominations proliferated, each with its own style and theological emphasis: these include the Methodists, Baptists, Quakers, Unitarians, Presbyterians and the Salvation Army, as well as smaller groups such as the Bruderhof.

The Pentecostal movement began in the United States at the turn of the twentieth century, and spread across the globe. It emphasizes the importance of the Holy Spirit speaking to the individual, and each church tends to be separate and independent. Healing often takes place during the service, and, in many churches, there is speaking in tongues.

There are a number of Christian groups, such as the Mormons, Jehovah's Witnesses, Seventh Day Adventists and Christian Scientists who may see themselves as being within the broad framework of

Commentary
Alison Seaman
Alan S. Brown

Christianity, but whose theologies would not be considered, strictly speaking, to fall within mainstream Christian thinking.

So Christianity is nothing if not diverse. The service is an unfolding of what it means to be a Christian. The variety of services allows the faithful to find a form of worship in which they can explore themselves and their relationship with God. So some services will be sacramental (based on ritual and symbol); others will place the emphasis on teaching and preaching; still others on silence and prayer.

In the Christian tradition, family and community life are very important. This might involve First Communion or Confirmation, attending a church school, or family prayer sessions. It also means joining in the celebration of the major events of the Christian year: Christmas, Easter or a pilgimage to a sacred shrine.

For some, the diversity of Christianity is its weakness, and there have been (and still are) times when Christians have come into conflict with each other and when they are highly suspicious of each other's motives. Paradoxically, however, this diversity has been a strength, for it has enabled the Church to withstand aggressive division and hatred, violence and conflict by allowing all who are touched by the love of God in Christ to find their own form of worship, a type of response which meets their need. The Franciscan friar and the Holy Fool may be poles apart, but they can, and occasionally do, make common cause in the name of God.

Judaism

Judaism may be a small religion numerically but it places its historical roots in the creation of humanity itself. One of the seminal moments for Jewish people was the Exodus when the great leader, Moses, led the Jews out of slavery in Egypt. The Hebrew Bible contains stories of the patriarchs who preceded Moses back to the first man and woman, but the Exodus, commemorated today in the Festival of the Passover (Pesach) has remained at the evocative and emotional heart of religious Jews.

The Hebrew Bible (consisting of the Torah, or first five books of the Bible, the Prophets and the Writings) describes a series of struggles: to know the will of God; to follow it; to put aside the temptations and delights of the godless; to recognize the love of God in the midst of persecution, and to accept His support in times of weakness.

Possibly two institutions have ensured the survival of the Jewish people. The first is the synagogue and through it the rabbis and strong community it has engendered. This is not to say that all synagogues agree with each other even if they have their place within the same Jewish tradition; but the different rabbinic teachings have, over centuries, created a living law based upon the written Torah. The energy, vigour and diversity of the synagogue have been of fundamental importance to the religion of the Jews for over 2,500 years.

The second institution is the family. There is the image of the Jewish family sitting down together at the Sabbath meal; coming together to celebrate the great Jewish festivals such as Pesach (Passover) and Sukkot (the Festival of Tabernacles); reflecting at Yom Kippur (the Day of Atonement) on their sinfulness before God. The round of story and ritual, humour and despair has honed the contemporary Jew.

Jews are dispersed throughout the world and few cultures have not been influenced by their creativity in the arts, science and the humanities. Scholarship is important in the Jewish tradition, and while the boy at his Bar Mitzvah may hardly be fluent in Hebrew, he will have studied hard to read his portion. Liberal and Reform synagogues nowadays have a Bat Mitzvah for girls and ordain female rabbis. The orthodox, however, do not recognize such changes and the ultra-orthodox often withdraw from the non-Jewish world as far as possible in order to live within the limits of their own society.

Most Jews in Britain are Ashkenazi, which means they come from a Northern and Eastern European tradition, but there are Sephardic Jews too, who follow a South European (Spanish) tradition. It is important to understand that while Jews may differ and follow the teachings of different rabbis, they are one people. There are orthodox Jews who live according to the halaha ('the way'), which is Jewish law as formulated by the rabbis; there are Reform and Liberal Jews who acknowledge the significance of the Torah but wish to bring it into contemporary life. There are others - like Masorti, who are traditional and radical at the same time; and the Lubavitch, who have roots in the Hasidic tradition and express a joy in life by praying through dance, song and laughter.

The sense of solidarity of tradition (with diversity) is the rock upon which contemporary Judaism has been built. It has helped Jews to survive when threatened and when isolated and separated from other Jewish communities. And behind it all is the call from God to be His people, His chosen, His Elect and the covenants made between Him and His people going back to the origins of time.

Islam

'There is no God but Allah and Muhammad is His Messenger'. This is the Shahadah, the basic fundamental statement of Islam. A Muslim is one who seeks to do the will of Allah (God) and willingly submits to that will. The revelation of Allah through the Angel Gabriel to Muhammad and recorded in the Qur'an took place over a twenty-year period (610-631 C.E) in the countryside around Mecca and Medina in Saudi Arabia.

The holy book of Islam, the Qur'an, recognizes that Jews and Christians (the 'People of the Book') have received revelations before through prophets sent by Allah, but their message has been distorted and misunderstood. It was necessary, therefore, to send a final and complete revelation through the person of Muhammad. Muhammad is the last (or the seal) of the Prophets.

Islam spread rapidly along the coast of North Africa through Spain and into France, and through Palestine and into the Balkan States. It was, and is, a popular religion with a clear message that there is no god

but Allah and that there are duties and responsibilities laid upon each Muslim, with a promise of a better, more equitable society under God.

Inevitably, there were splits and divergences. Most Muslims, probably 85 to 90 per cent, are Sunni, the others being Shi'ite. Non-Muslims often over-emphasize the differences but in reality they are not great and relate more to social and religious practices than to fundamental differences of theology. The essential difference is that Shi'ites believe their leaders, the Imams, form a chain of succession back to the Prophet. They also place emphasis on suffering and martyrdom because they are deeply aware of this aspect within the early history of Islam.

Islam is a fast-growing religion in the West. It has both a cultural and a religious face and it is not always easy for non-Muslims to distinguish between the two. This has perhaps led to a degree of misunderstanding and misrepresentation, for instance over subjects such as the Jihad (or Holy War) and the treatment of women.

The West owes a huge debt to the Islamic advance in the centuries after the revelation of the Qur'an and the richness of the civilizations it established. Innovations in art, literature, architecture and mathematics are but a few of the Islamic cultural legacies passed on to the West which are rarely recognized and acknowledged.

Regular prayer, self-discipline and the manner in which the language of the Qur'an has passed into the normal intercourse of Muslim life have formed a strong bond in the mosque and in the family. The latter is a central unit within Islam, with the security of marriage and family life providing the basis for the security of the faith.

The development of the mystical aspect of Islam, through the Sufi tradition, has to some extent caused a theological challenge: some Muslims find offensive the close mystical association of the believer with Allah. There are many 'Western' Sufis who adopt the Sufi mystical approach but are themselves outside the Muslim tradition.

Similarly controversial are the Ismaili sect, whose leader is the Aga Khan. Most Muslims would not regard them as Muslim at all. They trace their origins to Ismail, whom they consider the rightful heir to the sixth Iman. They believe that only they know the true meaning of the Qur'an.

Although the Qur'an is in Arabic, and the final revelation was given to an Arab, the success of Islam lies in its ability to acknowledge and hold on to its roots while engaging with the world's diversity of races, cultures and languages. The pattern of affirmation of the Oneness of God, prayer, *zakat* (religious giving), pilgrimage and fasting transcends nationalism, and the focus on Mecca during prayer for all Muslims is a powerful symbol of the unity of God and the unity of their religion.

Hinduism

Hinduism is a way of life whose origins are lost in time. Even the word 'Hindu' is a Western invention intended to describe the peoples living on the other side of the River Indus. Most Indian people are Hindu, but this does not mean they believe the same things, worship the same god or even celebrate the same festivals. Hinduism is a richly diverse collection of beliefs and practices, with each local community or village having its own distinct identity. It is impossible in Hinduism to separate religion from everyday life.

Central to the Hindu religion is God, described as 'Brahman' - the supreme being or supreme spirit that is formless and can be found everywhere, in people, animals, birds, plants or a combination of these. Hindus express their understanding of Brahman in different ways and worship Brahman in different forms. This is why Hinduism has many gods and goddesses, each representing some form of Brahman.

The gods may have different roles and may be worshipped for different things. Lord Ganesh, the elephant-headed god, is worshipped for good fortune during New Year celebrations, while Lord Rama is usually worshipped as an avatar (a god who came down to earth) of Lord Vishnu. Gods and goddesses often appear in pairs. Radha and Krishna form one such divine partnership. They are a popular focus of worship both in the home and in the temple.

The temple is the home of the images or statues of gods and goddesses. They are looked after, cared for and offered food as if they were human, and visitors to the temple are there as guests of the deities. The temple can also be visited during festival times and it is a meeting place for the local community. The home, however, forms the focal point for Hindu worship. The household shrine is a personal commitment to Brahman reflected through the believer's own deity. The stories and attributes of the deity are a source of strength, courage and insight for the devotees in their daily life.

There are several New Year festivals associated with the various Indian calendars used in different parts of India. The festival of Diwali is often called the Festival of Light and is probably the most widely celebrated of all. The story of Rama and his wife Sita is told and the triumph of good over evil, light over darkness is celebrated.

In the midst of diversity there is, within Hinduism, a tolerance of other spiritual paths and a deep respect for the devout spiritual person. It is this ability to see God in all things and to believe that there are many paths to God that is one of the most distinctive aspects of the Hindu tradition.

Hinduism has spread from India throughout the world. The coming of Vivekananda (a disciple of the Bengali Holy man Sri Ramakrishna) to the West at the end of the 19th century paved the way for the Western 'discovery' of Indian philosophy. He promoted a particular strain of Hindu thinking, 'Advaita Vedanta', which describes the non-dual aspect of all things (God is believed to be in everything), and he taught meditation, a practice deeply rooted within Hinduism. While the name of Vivekananda has been overtaken in the course of the century, he profoundly influenced writers such as Christopher Isherwood,

Aldous Huxley and Allen Ginsberg, all of whom sought to popularize the perennial philosophy.

Although Hinduism is not considered to be a missionary religion, some Hindu movements have sought to recruit members. In the West, the group popularly known as the Hare Krishna movement (ISKCON) is probably the best known. In the 1960s it gained the reputation of being a 'hippy' cult, but it has now become accepted by most Hindus and has shed its cult status.

Swaminarayan was a 19th-century holy man from Gujarat, who was recognized as the highest manifestation of God in human form. ('Narayan' is a word for 'God'). Those who follow the saint's teaching practise one of the many forms of Hindu devotionalism. Most, but not all, Swaminarayans are Gujarati and therefore give the group a strongly ethnic flavour.

Transcendental Meditation, or TM, was brought to the West by Maharishi Mahesh Yogi in the 1950s, becoming more widely known in Britain and America when The Beatles took it up in the 1960s. TM courses teach a simple mantra meditation technique in which a Sanskrit word is repeated. In Britain, TM has been practised by people from all walks of life. Some wish to use meditation techniques simply to relieve stress; others have gone on to develop a deeper involvement in the movement and its spiritual and philosophical teachings.

Brahma Kumaris practise Raja yoga, which does not involve any mantras or special postures, but rather sitting with the eyes open in a process believed to bring realization of The Supreme Being. The movement was founded in 1937 by a devout Hindu, Dada Lehk Raj, and its first branches in the West were established in 1971. Women have come to take a leading role within the movement and it has been closely associated with various United Nations peace initiatives.

Sathya Sai Baba has attracted a large following in Britain. This charismatic figure is a Guru (teacher – the word literally means 'from darkness to light') from Andhra Pradesh whose first followers were largely from South India. His influence spread and the movement has become popular among British Hindus, including some Western devotees. Worship takes a similar form to traditional Hindu practice with a particular emphasis on devotion to God, believed to be incarnated in Satya Sai Baba.

Buddhism

There are many different forms of Buddhism but all follow the Buddha and his teachings. Siddhatta Gotama lived in India around 2,500 years ago and was given the title Buddha, which means Awakened or Enlightened One, by his followers. Gotama taught that there is no Ultimate Being with the power to bring each person to Nirvana (Enlightenment). All people must bear the responsibility for their own lives and its consequences in this life and those to follow.

Buddhists need not be monks, but the belief in rebirth and the natural order of cause and effect (*karma*) places the ordained in a special category where they are treated with respect and reverence.

Today there are nuns, though at the time of Gotama, the Sangha consisted only of men.

Essentially non-violent, Buddhism is built upon a deep commitment to the Buddha, the Dhamma (the teaching of the Buddha) and the Sangha (community of lay and ordained Buddhists). These are sometimes described as the Three Jewels. It is these three essential elements which are taken as guidance on the path of life. They provide safety (another description is the Three Refuges) but they can also allow the individual to grow in life, wisdom and compassion.

Many British Buddhists have found their way into Buddhism through meditation, from which they have moved into a deeper exploration of Buddhist teachings, ethical stances and devotional practices. Examples of traditions which have become well established in Britain are Theravada, Zen, Tibetan and the Friends of the Western Buddhist Order (FWBO). Growing from its Asian roots, Buddhism has spread throughout the world, often being accommodated and expressed within the cultural setting. This can be seen in the way in which some forms of Buddhism have been enculturalized within the Western intellectual tradition.

Meditation and stillness capture something of the essential truth of Buddhism. If, in the practice of meditation, a person can leave the concerns of life and the 'attachedness' that drives each of us, then a foot has been placed on the path to Nirvana. Different forms of meditation are practised by both lay and ordained Buddhists. It is considered important in life to learn to 'let go', for if this can be achieved then life's 'problems' are placed in a proper perspective and disappear. Being at peace, reflecting on the teaching of the Buddha, enables the Buddhist, whether lay or ordained, to approach the world with the right understanding and right action. The strong motivation for this is to move away from evil and suffering towards goodness. With this, it is believed, comes an understanding of the purpose of life and the truth about oneself.

Sikhism

Behind much Sikh practice lies a powerful motivation to serve God in everyday life, particularly through service to others. A mystical path of devotion is followed, built upon peace, love and non-violence. Sikhism began as a religious movement in the Punjab, in North India, in the mid-1400s C.E. A Hindu, Nanak, became the first Guru, or religious leader, of the Sikhs. This was at a time when the caste system dominated all aspects of life in India and Guru Nanak's mission was to bring his followers back to an understanding that all people could come to know and experience God, whatever their caste, gender or race. His followers were taught that *Moksha* (liberation) could be attained by all through God's grace.

Ten Gurus, in all, taught this message and the Sikh community developed into a distinct religious group. The movement was strengthened by the compilation of a book of teachings of the Gurus. Called the Adi Granth, this also included the work of Hindu and Muslim teachers. The tenth Guru, Gobind Singh,

declared the end of the line of human Gurus and conferred guruship on the Adi Granth, now known as the Guru Granth Sahib.

The Gurdwara, the place of Sikh worship, is the home of the Guru Granth Sahib. This is cared for with great reverence. During the daytime it is placed at the front of the prayer hall, on a raised platform under an ornate canopy, where it forms the focus of worship. Both men and women read aloud to the gathered community and hymns from the book are sung. An important part of Sikh worship is the communal sharing of food. A sweet mixture of sugar, flour and ghee, *Karah prashad*, is distributed to all from one serving bowl to demonstrate equality and common fellowship. Worship also includes a community meal called *Langar*, which is prepared and served by men and women and shared by all.

The turban, worn by some Sikh men, is a clear statement of religious affiliation and one with which Sikhs have become clearly identified, particularly in the Western world. It is worn from the time a Sikh becomes a member of the Khalsa, the world-wide community of initiated men and women (but it is not a requirement for women). Members of the Khalsa also symbolize their attachment and commitment by wearing five signs, mostly items of dress, known as the Five Ks, because in Punjabi their names all begin with the letter K. These are Kes (uncut hair), Kanga (a small comb), Kara (an iron or steel bracelet), Kacch (loose shorts worn as an undergarment) and Kirpan (a sword with a curved blade). By wearing them, Sikhs obey the command of Guru Gobind Singh to the first five members.

Sikhism is a tolerant religion, and there is an openness towards and support of people of all faiths in their search for God.

Baha'i

The holy man at the heart of the Baha'i religion was the Bab. He lived in Iran in the first half of the 19th century and was executed in 1850. He gave new meaning to Islamic laws and longed for the coming of the next prophet. After his death the real founder of Baha'ism, Baha' u' llah continued his work. He died in 1892 and his son, 'Abdu'l Baha, took over the leadership until his death in 1921. The Baha'is believe that all religions are divine; that there is one force for good in the world (for evil is the absence of good); that each religion paves the way for the next one; and heaven is nearness to God, hell is being far away.

Their regime is strict – they pray daily, take no alcohol or drugs, and fast between sunrise and sunset from 2 to 20 March every year. Children formally become adults at 15 and then take on the full responsibilities of being a Baha'i.

Baha'is are truly a world community, recognizing the equality of women and the importance of peace and pacifism. Their faith is not Islam although they are often perceived as being derived from it. They have their own Holy Book, the Book of Laws (*Kitabi Aqdas*).

Jainism

Jainism has had 24 prophets in its long history. The latest of them, Mahavira (Great Hero), lived about 600 B.C.E. The faith celebrates those who have, through heroism and insight, gained liberation and then revealed the path to others.

Faithful Jains will not take life; nor will they eat any meat, or even eggs. They are the strictest vegetarians. This means Jains will not be involved with the army, butchery or farming. Jain monks are most popularly known for sweeping the path in front of them so as not to tread on any living being. The Jain lay person will tread most softly.

The Jains in Britain often follow professions such as pharmacy, medicine and law. Material wealth and comfort are strongly discouraged.

The essential Pathway within Jainism is that of self-discipline and careful conduct, for all knowledge is within each of us and we must remove the clutter and confusion caused by impression and desire. The heroes show the way, and all humans can achieve the highest state; we are potentially omniscient beings.

Zoroastrianism

Zoroaster probably lived about 1200 B.C.E. He was an Iranian prophet known, in his own country, as Zarathustra. He taught that there was only one God, called Ahura Mazda. In the world created by Ahura Mazda there was a being called Angra Mainya, the Hostile Spirit, but the world was a place where evil could be overthrown.

Ahura Mazda created the 'Holy Immortals' (Amesha Spentas) to help him. Humans should worship God and the Immortals. They would then save not only themselves but the world as well.

While the Hostile Spirit wins some victories on earth, he will lose the final battle because good will always triumph over evil in the end. At the Last Judgment the dead will rise, those who are blessed will be re-united with their bodies and Ahura Mazda will descend to reign in glory.

There are relatively few Zoroastrians in Britain, but the teachings of Zoroaster are often regarded as a natural bridge between the religious and philosophical teachings of the East and West.

Taoism

'Taoism' means, literally, 'Teachings of the Way'. The religious forms of Taoism include the quest for immortality, mental and physical discipline and interior hygiene. Taoists often describe life as being like a river, and that harmony lies in 'going with the flow'. 'Yin' and 'Yang' are the ancient Chinese names for the two opposite and complementary forces in nature. Yin force is associated with the femine, the earth, night, cold, moon and passivity. The Yang force is associated with the masculine, the heavens,

light, heat, the day, sun and activity. The whole of the natural order is explained in terms of the balance between these two forces.

Wicca (Witches)

The wicca have suffered from the use of terms like 'pagan' and 'witch', yet these emotive words are a travesty of what the wicca do. Rooted deeply in pre-Christian religious practice, wicca seek to be in touch with the powers of the natural world. They live by the cycle of the seasons, the rhythm of the natural order, human and otherwise. They tend to have a strong following in rural areas. The persecution of witches in past centuries appears to have been as much a persecution of women as having any direct religious significance. Today there is an unfortunate misrepresentation of the wicca by a prurient society encouraged by popular and ill-informed journalism.

Druidry

The Druids were pre-Christian and pre-Roman. They were the leaders and priestly caste of society in Britain before the Romans came with their own gods and the 'new' religion of Christianity arrived in Britain. Currently, the last century or so has seen a revival of the Druids, best known in Wales, where it is expressed most publicly through a celebration of Welsh literacy and nationalism. Some 1,500 to 2,500 years ago, they were an influential element in society, controlling religious practice, justice and the general ordering of society. Today, Druids find strong affiliation with ancient sites like Stonehenge and Avebury, for they capture something of the mysterious cultic past in which the cycle of life revolved around the seasons, the sun and the moon.

Shamanism

The word 'shaman' is usually reserved for the person in a 'primitive' society who is deemed to have special gifts. This may include the power to heal, to teach, to preserve the rituals and rhythms of the social structure. For this reason the shaman is set apart from the normal activity of society. He or she is recognized as unique and is both feared and respected; the shaman 'sees' into the hearts and minds of those within his or her circle. In Britain, the shamanic tradition sees itself as a revival of our Celtic pagan heritage.

Rastafari

The original Rastafari were led by Marcus Garvey (recognized by some as the reincarnation of John the Baptist). They believed the coronation of Ras Tafari (Haile Selassie) as Emperor of Ethiopia in 1930 fulfilled

a Biblical prophecy. Haile Selassie was looked on as a living god, believed by some to be the Second Coming of Jesus Christ, and Ethiopia was the place to which the Rastafari should return.

There are no churches; but beliefs are based on the Bible and the Ethiopians are believed to be the Chosen People of God. Christianity, as practised world-wide, is considered to be a false representation of the religion, for it preaches a god who is not black. Rastafari are concerned with justice, freedom and peace. God is within all and is called 'JAH'. Rastafari are mainly vegetarian with strict dietary rules.

Rosicrucianism

Rosicrucians practise a mix of alchemy, astrology, theosophy, and the kabbalistic interpretation of Scripture. The cross, for example, is not a symbol of atonement but represents the human body. In the rose at the centre is the pure fluid to overcome the passion-filled blood of the human race. The term Rosicrucian emerged in 1614 with the appearance in Germany of three anonymous publications about a secret Rosicrucian order. The word comes from the Latin meaning 'rosy cross' and may be linked to an allegorical figure of the 14th century, Christian Rosenkreuz. Many Rosicrucians, however, believe their origins lie in ancient Egypt.

Some Masonic lodges today have an optional degree called the Rose Croix of Heredom. The best-known modern group is the Ancient and Mystical Order Rosae Crucis of California (AMORC), founded in New York City in 1915. AMORC groups in Britain practise techniques to bring themselves into mystical communion with God.

Spiritualism

When the Fox sisters of Hydeville, New York, discovered that they could communicate with the spirits of the dead, their skills as mediums attracted widespread interest. This was in the 1840s, and from these beginnings a movement developed in most Western countries, which had its roots in Christianity but focused on making contact with the spirits of the dead. Its attraction for some is the apparent evidence it seems to offer of an afterlife. Services or 'seances' are held either in a Spiritualist church or private home. The medium makes contact with a guide or spirit helper in order to establish communication with dead friends or relatives. Reports have been made of this leading to the visible manipulation of objects, or of the appearance of ectoplasm. This phenomenon is believed to be the spirit appearing in tangible form and emerging from the medium's body.

Psychosynthesis

Psychosynthesis is not a religion but a therapy, part of the school of Trans-Personal Psychology. It does have, however, a philosophy akin to that of the religious traditions in which the Self is the source of all wisdom. In this way, psychosynthesis is one of a burgeoning group of self-discovery programmes in which the boundaries between therapy and spirituality are merged.

'Non-Affiliated Believer'

For some, the structure of religious affiliation is inappropriate. To tie oneself to a 'religion' is to deny the personal integrity of the spiritual quest. This can be a hard path to tread, for the language and thought forms of a culture create a framework for religious expression, and it does not come easily to divest oneself of all religious and cultural baggage. In Britain today, many people see themselves as following a spiritual path, but their numbers, by definition, do not show up in any census of religious affiliation.

Bibliography

Bowker, J. *World Religions. The Great Faiths Explored and Explained*, London 1997

Campbell, Eileen and Brennan, J.H. *The Aquarian Guide to the New Age*, Glasgow 1990

Campbell, Joseph *Masks of God*, London 1992

Cole, W.O. *World Faiths: Sikhism*, London 1998

Erricker, C. *World Faiths: Buddhism*, London 1999

Jung, C.J. *Memories, Dreams, Reflections*, London 1989

Krishnamurti and Bohm, David *The Ending of Time*, London 1988

Maqsood, R. *World Faiths: Islam*, London 1999

Pilkington, C.M. *World Faiths: Judaism*, London 1997

Smart, Ninian *The Religious Experience of Mankind*, Glasgow 1969

Smith, J.Z. (ed.) *The Harper Collins Dictionary of Religion*, London 1996

Vanitkar, V.P. and Cole, W.O. *World Faiths: Hinduism*, London 1999

Weller, P. (ed.) *Religions in the UK. A Multi-faith Directory*, Derby 1997

Wilbur, Ken *A Brief History of Everything*, Dublin 1996

Wolffe, J. (ed.) *The Growth of Religious Diversity. Britain from 1945*, London 1998

Young, J. *World Faiths: Christianity*, London 1999